IMAGES
of America

DETROIT TELEVISION

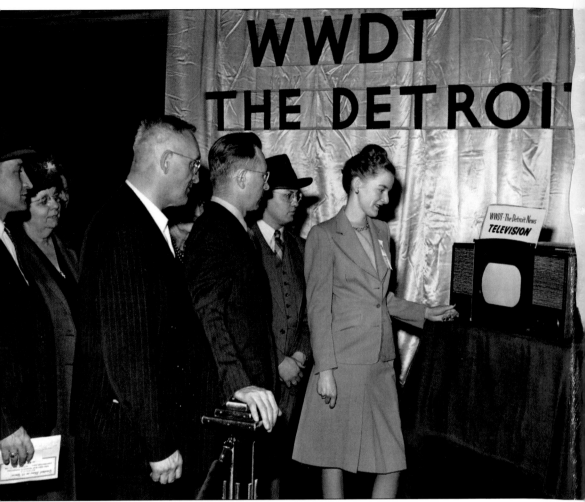

A curious crowd checks out the first television broadcast in Detroit at the city's convention center in October 1946. (Courtesy the *Detroit News*.)

ON THE COVER: Sagebrush Shorty and Skinny Dugan check out the latest models at Woody Pontiac in Hamtramck, Michigan.

IMAGES
of America

DETROIT TELEVISION

Tim Kiska and Ed Golick

ARCADIA
PUBLISHING

Published by Arcadia Publishing
Charleston, South Carolina

Printed in the United States of America

Library of Congress Control Number: 2009925643

For all general information contact Arcadia Publishing at:
Telephone 843-853-2070
Fax 843-853-0044
E-mail sales@arcadiapublishing.com
For customer service and orders:
Toll-Free 1-888-313-2665

Visit us on the Internet at www.arcadiapublishing.com

To my wife, Patricia, and to my three children,
Caitlin, Amy, and Eric. – Tim Kiska

To my wife, Sherry, who puts up with my foolishness. – Ed Golick

CONTENTS

ACKNOWLEDGMENTS

Thanks to Elizabeth Clemens and Mike Smith at the Walter P. Reuther Library, Wayne State University; John King and Toni Caron at John K. King Books; Gail Pebbles, Janella Wine, and Sandy McPhee at Channel 7; Sonny Eliot at WWJ-AM; Bob Stevens, formerly of Channel 4; Ken Martinek, Murray Feldman, Dana Hahn, and Keith Stironek at Channel 2.

INTRODUCTION

Television has changed this country and the world. From political discourse, to music, to commerce—nothing has escaped the ubiquitous influence of "the tube." It seems like a force as big as the weather, impossible to tame, changing course at will. But the medium was once local, friendly, and entertaining. Channel 2 (WJBK-TV), Channel 4 (WWJ-TV and later WDIV-TV), and Channel 7 (WXYZ) entertained and informed Detroiters with a casserole of programming that varied from adventure shows, polka shows, rock music shows, bowling shows, and news—all produced by Detroiters.

"They were ours," recalls Tom Ryan, a Detroit native who made his mark in local television as Sergeant Sacto in the 1960s and Count Scary in the 1980s and 1990s. "They were our family. When you went home, you'd watch network shows like Hopalong Cassidy. You liked Hopalong and the network shows, but they were far away. The local shows were part of you. They were your neighbors. They were in your hometown. They were friendlier." Sportscaster Ray Lane said, "I've been to a lot of cities. Here [Detroit], TV was more *personal*."

This book celebrates the medium's history. Even more than that, it celebrates television when it was truly local. Each of the three major stations in Detroit had their own character.

Channel 4 (WWJ-TV) was the first station to hit the airwaves. It was owned by the Evening News Association, which also owned the *Detroit News*, the city's biggest newspaper. It had the biggest and most-respected television news operation in town from television's beginnings in the late 1940s until the mid-1960s, when Channels 7 and 2 jumped into the game. It had George Pierrot, Milky the Clown, Sonny Eliot, Mort Neff, and NBC's prime-time lineup. McHugh and Hoffman, Inc., a research company surveying the attitudes of Detroit television viewers, had this to say about Channel 4, "The *Detroit News* is an old, powerful, and successful institution on the Detroit scene, and there is a minimum of animosity directed toward it. By and large, it is a well-liked paper, and those attitudes of respect and approval of the *Detroit News* carry over in modified forms to WWJ in people's feelings about it."

If Channel 4 was old and established, WXYZ-TV (Channel 7) was rock-and-roll. The American Broadcasting Company (ABC) bought the station in 1946 (along with Grand Rapids's WOOD-TV) for $3.65 million. ABC was the newest network in the country, dwarfed by the bigger, more-established CBS and NBC operations. During the early and mid-1950s, Channel 7 was run by John Pival, a crazed, drunken genius. He once came through the newsroom with a gun, looking for an employee. On another occasion, he chased his executives out of his home with an ax. He excesses were legendary. So was his eye for talent. A young Cincinnati deejay by the name of Soupy Sales came to Detroit looking for work. Nobody would hire him, but Pival looked at Sales and saw potential. Sales became one of local television's biggest stars, and he went on to some network fame, serving as a replacement for Kukla, Fran, and Ollie during the summer of 1955. Pival saw a young *Associated Press* reporter by the name of Dave Diles at a country club roast. Pival, drunk and wearing sunglasses at 10:00 p.m., approached Diles and said, "My name

is John Pival. I run Channel 7, and I'd like to hire you." Diles told Pival, "Why don't you call me when you sober up."

Channel 7's success kept ABC afloat in the early and mid-1950s. The ABC-TV network lost money in 1953 and 1954 and reported only a small profit ($481,138) in 1955. ABC's owned-and-operated stations kept the network afloat—particularly Detroit and Chicago. In Detroit, ABC saw $4 or $5 in profits for every $1 it invested here.

Channel 2 (WJBK-TV) had a less flashy history. It was purchased by Toledo businessman George Storer in 1947 for a mere $550,000. Its association with CBS made it one of Detroit's more popular stations. However, Channels 4 and 7 eclipsed it in local programming. Channel 2 made its mark in one area during the 1960s—news. With the team of Jac Le Goff, John Kelly, Jerry Hodak, and Van Patrick at the desk, it became a local news-broadcasting model—so much so that the better-financed ABC lured much of its talent away with wheelbarrows of money.

Local television blossomed during the late 1960s. A nine-month newspaper strike in 1967–1968 proved a bonanza for the medium. Revenue jumped from $31 million in 1967 to $38 million in 1968—a 22-percent boost. Profits went through the roof, going from $12.8 million to $16.6 million during the same period.

Two things changed the landscape for good. Syndicated programming made it easier for television stations to buy higher-quality programming at a lower price. Rather than produce an entire show at greater expense, it became easier to buy a national show with greater access to the big stars. How could any local television compete with *The View*, *Oprah*, or *Ellen*?

Cable television proved to be the death knell for the local medium. Entire cable television networks do what some of Detroit's early stars did. George Pierrot took viewers around the world, but there is now the Travel Channel. Lady of Charm served up valuable cooking and home decorating tips, but there is now the Food Network and Home and Garden Television. Mort Neff explored the woods and streams of northern Michigan, but there is now the Outdoor Channel. Ed McKenzie and Robin Seymour gave viewers rock-and-roll, but there is now MTV and VH1. Programming on these cable channels is high quality, often even brilliant. The last locally produced, daily, non-news program went off the air in 1995. All that is left is news.

The medium may be better than ever, but it is a lot less local.

One

EARLY DAYS

Detroit television was born in an attic in downtown Detroit's Penobscot Building. A team of broadcasters and executives with the Evening News Association (owner of the *Detroit News*) walked to the 47th floor of the Penobscot Building on October 23, 1946, and successfully mounted the Motor City's first television broadcast. Fran Harris, one of the on-air participants, recalls the scene as a ghastly site. Early television cameras had difficulty separating colors, so talent went before the cameras in blue makeup. "Blue lips, blue cheeks, and blue eyebrows, an appalling off-camera vision," she later wrote. The broadcast included a presentation by Dave Zimmerman, host of WWJ-AM's *Coffee Club*, who also served as the emcee. Harris talked with a French chanteuse. A crowd at the city's convention center took it all in.

At first, television was taken as a novel experiment, and nobody objected when things went south. Channel 7's Pat Tobin and Johnny Slagle would routinely chat in front of the cameras, run out of things to say, excuse themselves, and return after they planned their next move. "We'd look at the test patterns and ask each other, 'Isn't that the best test pattern you've ever seen?'" recalls Tom Ryan, a Detroit native who later went on to work in both radio and television. Sonny Eliot recalls, "Somebody would hear a jazz band at a nightclub and say, 'Hey, come down to the studio and do a set.' And they would. Nothing was planned."

Channel 4 began a schedule of regular programming in 1947, with Channels 2 and 7 following suit the next year. For the people working in the business, the hours were long and the money sparse, but it was great fun. "It was a ball, just one happy family . . . we loved what we were doing," remembers Ron David, who joined Channel 7 in 1952 and worked there throughout the 1950s.

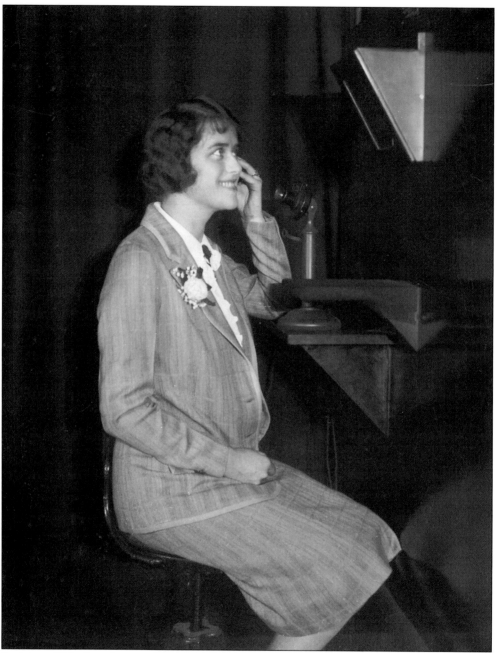

In this preflight for television, Ethel Mahoney checks out a new television sometime before 1931. The medium was well into development during the 1930s, but World War II delayed the commercial introduction of new sets. (Courtesy Walter P. Reuther Library, Wayne State University.)

In this preflight for television, singer Rosemary Calvin tries a test run with Detroit Edison engineers on April 17, 1939. Calvin went on to sing with Vaughn Monroe between 1940 and 1946. Her big hit with Johnny Bond and His Orchestra was "You Broke My Heart With Bebop." (Courtesy Walter P. Reuther Library, Wayne State University.)

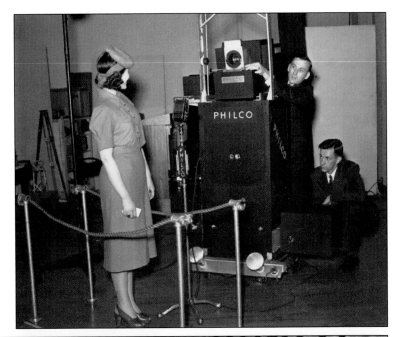

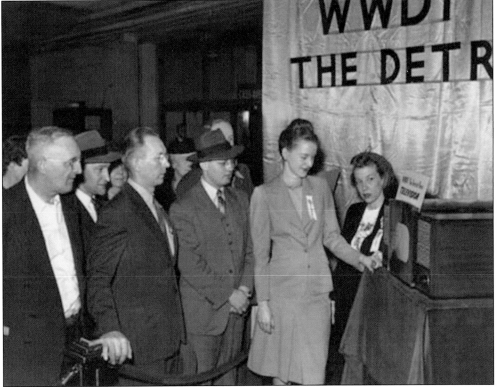

The first television signal in town went from atop the Penobscot Building to this waiting crowd at the city's convention center in October 1946. This group had it easy, as they simply could stand and watch. Folks producing the broadcast had to walk up several flights of stairs to the set, because the Penobscot Building's elevator did not go that far. (Courtesy the *Detroit News*.)

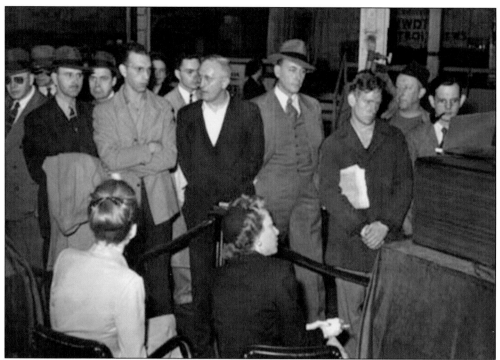

This is another shot of the first television broadcast in October 1946 with a crowd paying rapt attention. Federal Communications Commission (FCC) chairman James Coy said that year, "I foresee the day when television will be will the most powerful instrument of communication ever devised. The most universal and most effective purveyor of educational information, culture, and entertainment." Author John Steinbeck was also quoted that week. He called the new medium "an octopus, a monster." (Courtesy the *Detroit News*.)

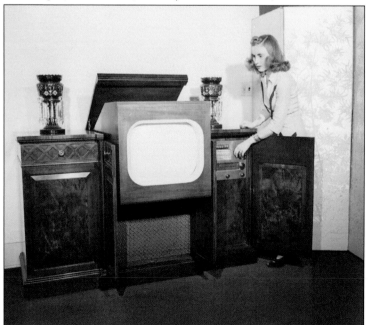

Pictured is an early television display at Grinnell's in downtown Detroit in October 1946—the same year that Channel 4 signed on the air. Department stores advertised sets for as high as $985—almost $11,000 in 2010 dollars. Any home with a television set instantly became the most popular home in the neighborhood. (Courtesy Walter P. Reuther Library, Wayne State University.)

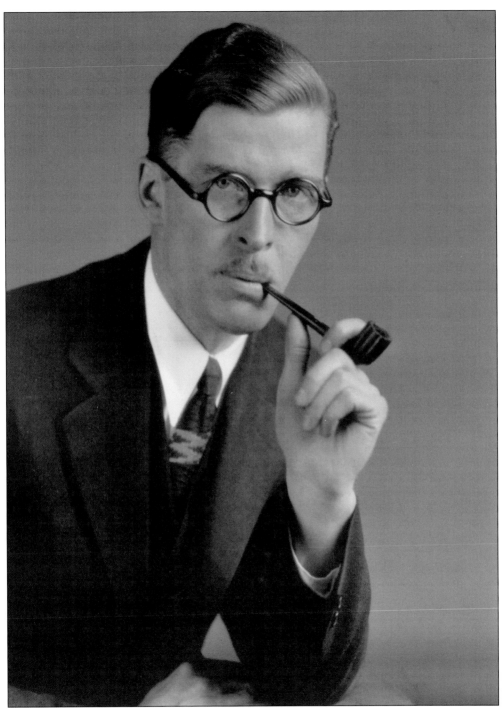

This distinguished-looking gentleman, Herschell Hart, was Detroit's first television and radio critic. He began work at the *Detroit News* in 1924, later covering the nightclub beat for the paper. His radio and television column, *Air Gossip*, was among the paper's most popular features. He had four television sets in his home when having even one was considered a great luxury. He would watch television at home and send his copy to downtown Detroit in a cab. (Courtesy Mary and Colby Hart.)

Fran Harris is thought to be the first female newscaster in Michigan and worked for WWJ-AM during World War II. She also appeared on Detroit's inaugural television broadcast in 1946. Harris was a serious, well-read journalist who earned a Peabody Award in the late 1940s for an investigative series for radio. (Courtesy WDIV-TV.)

Smiling for the camera is Madeline Jones, Miss Television 1948. (Courtesy Walter P. Reuther Library, Wayne State University.)

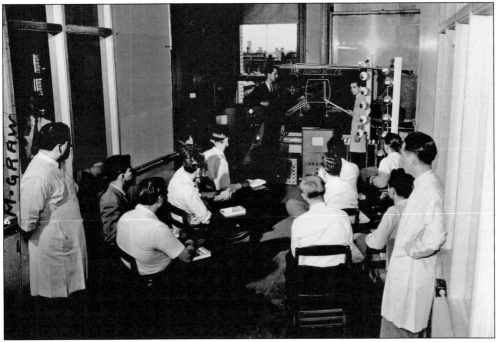

This is Detroit's first television classroom, seen in October 1947; the medium was thought to have great educational possibilities. The photograph was most likely shot on or near the campus of Wayne State University. (Courtesy Walter P. Reuther Library, Wayne State University.)

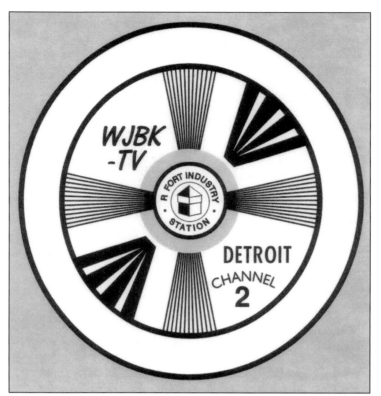

Pictured is WJBK-TV's test pattern. People often marveled at—and studied—the patterns during television's early days. Recalls Mary Lou Zieve, who worked in advertising during the 1950s, "We'd look at the pattern. Somebody would come in the room and ask, 'Why are you looking at the test pattern?' The answer would be, 'Something will happen sooner or later.'" (Courtesy Ed Golick.)

Johnny Slagle hosted Detroit's first popular television talk show, pairing with Pat Tobin in what would become a model for numerous shows up to the present-day *Live with Regis and Kelly* program. Pat and Johnny would banter about whatever interested them, and what interested them interested a lot of people. The duo hosted a baby contest, drawing 54,000 pieces of mail in less than week. (Courtesy the *Detroit Free Press*.)

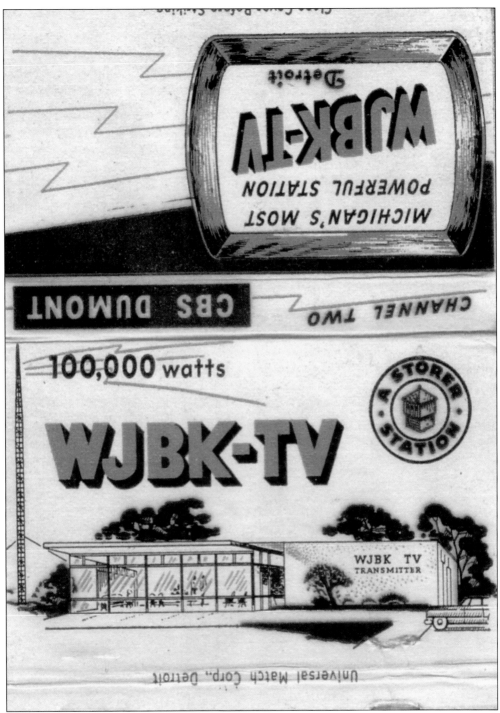

During television's early days, stations would put their logos on just about anything. Here is a book of matches, which salesmen would pass out to prospective clients. WJBK-TV was an affiliate of both CBS and DuMont. DuMont went out of business in 1955. (Courtesy Ed Golick.)

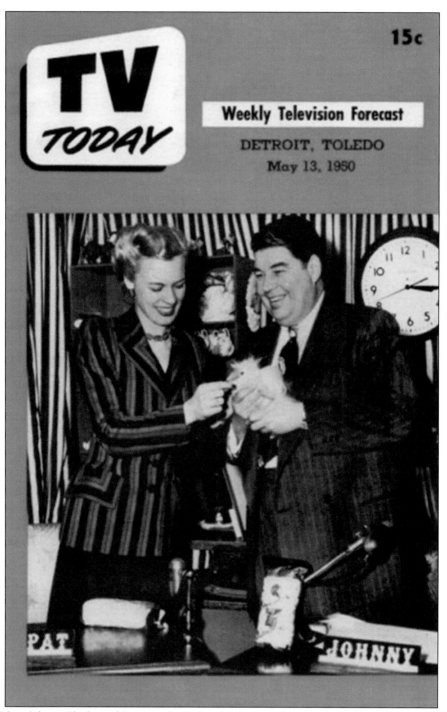

Pat Tobin, Johnny Slagle, and Ragmop the Guinea Pig are seen here on the cover of the May 13, 1950, issue of the weekly television magazine *TV Today*. The program lasted until 1951. Slagle later hosted a wrestling show, but he spent the remainder of his broadcast career in radio. Tobin abandoned her Detroit television career and left town. Ragmop's popularity boosted the sales of guinea pigs across Detroit. (Courtesy Ed Golick.)

Pictured are Detroit's first television stars, Johnny Slagle behind the GE podium and Pat Tobin immediately to the left. The *Pat 'n' Johnny* show was said to be the first hit television series on Detroit television. With talk, music, and fun, it looked and sounded like today's *Live with Regis and Kelly* show. The *Pat 'n' Johnny* show went on live from the Macabees Building, near the campus of Wayne State University. (Courtesy WXYZ-TV.)

Channel 7 went on the air in 1948 with this test pattern. The station subsequently made a bundle for its owner, the American Broadcasting Company. During the network's lean years in the early and mid-1950s, Detroit and the ABC-owned station in Chicago kept the corporation from going broke. Early television viewers used the test pattern to align the signal on their sets. (Courtesy WXYZ-TV.)

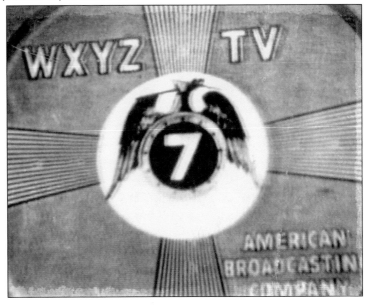

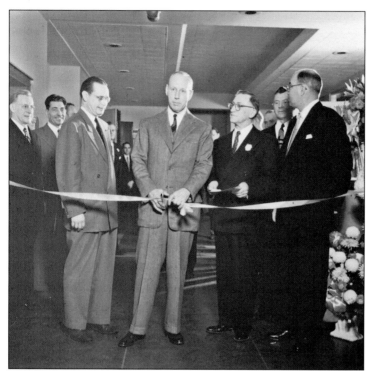

This is the ribbon-cutting ceremony at Channel 4's new studio on November 17, 1952. In front from left to right are James Whitcomb, Edwin K. Wheeler, Warren S. Booth, Mayor Albert E. Cobo, and Joseph H. McConnell. Booth ran the Evening News Association, which owned Channel 4. Wheeler ran the station, and he is often credited as the driving force behind the station's excellent reputation during the early days. (Courtesy Walter P. Reuther Library, Wayne State University.)

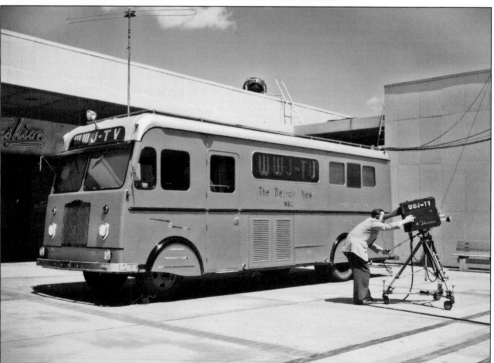

Here they are, two of post-war America's biggest game-changers: television and the shopping mall. A Channel 4 crew is at the Northland Shopping Center in 1956, two years after the mall opened. (Courtesy Walter P. Reuther Library, Wayne State University.)

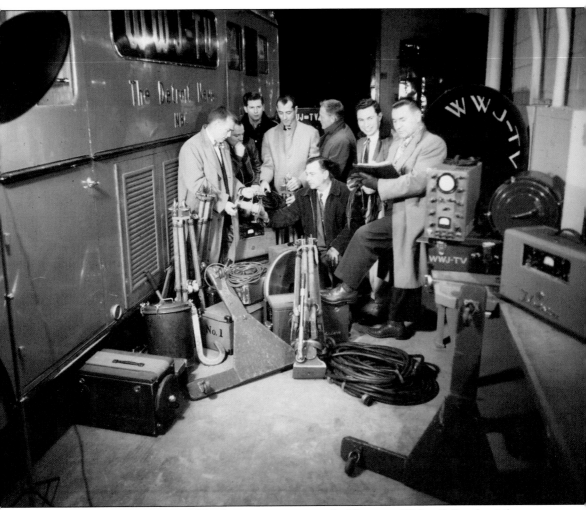

A Channel 4 crew is pictured loading up a remote truck. (Courtesy Walter P. Reuther Library, Wayne State University.)

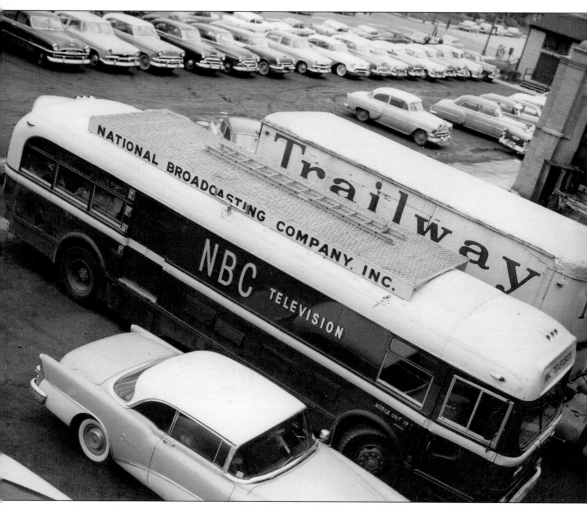

NBC visits Wayne State University in 1955. Even then, parking spaces at the area's biggest commuter school were at a premium. (Courtesy Walter P. Reuther Library, Wayne State University.)

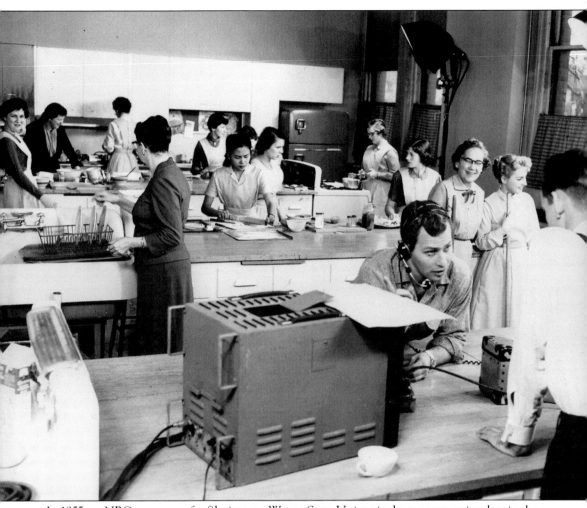

In 1955, an NBC crew preps for filming at a Wayne State University home economics class in the school's Old Main Building. (Courtesy Walter P. Reuther Library, Wayne State University.)

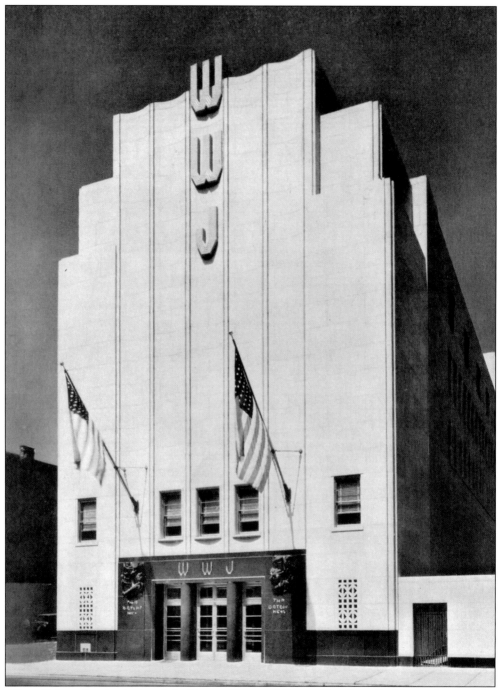

Albert Kahn, who also designed the Detroit News and Detroit Free Press Buildings, designed the original WWJ radio studio. A three-level television facility was added to the building in 1952. (Courtesy Ed Golick.)

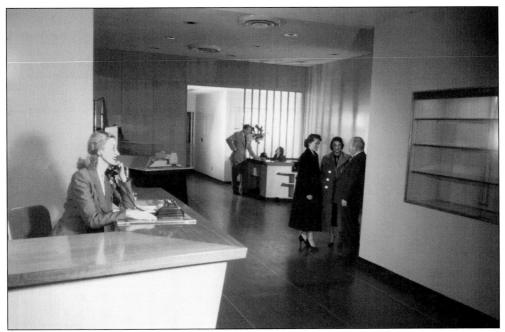

Channel 4's reception desk is pictured in downtown Detroit during the *Mad Men* era. The station's radio-television complex was the envy of local broadcasters across the country. Now the station's receptionist sits behind bulletproof glass. (Courtesy Walter P. Reuther Library, Wayne State University.)

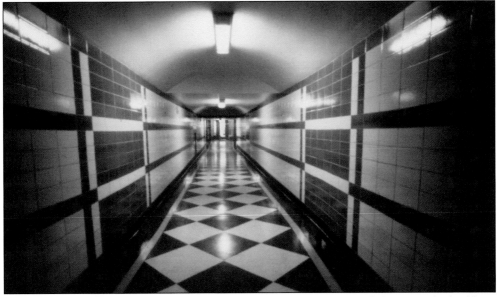

Beneath West Lafayette Boulevard in downtown Detroit ran a "tunnel" between the buildings housing the *Detroit News* and Channel 4. The tunnel was long thought to be an urban myth, but as the photograph illustrates, it was not. The *Detroit News* and Channel 4 shared common ownership, which was a great strength in television's early days. *Detroit News* pressmen also used it as their secret shortcut into Channel 4—and into the Adams Bar, directly adjoining the station. The tunnel has long since been blocked off. (Courtesy Walter P. Reuther Library, Wayne State University.)

Channel 7 director Mort Zieve (center) sits with Dee Parker, or "Auntie Dee," and Jimmie Stevenson (right), Parker's musical director. Zieve wrote and produced Dee's show, along with Soupy Sales's nighttime show, and Lou Gordon's Saturday night news show. He left Channel 7 to work in Detroit advertising. (Courtesy American Federation of Television and Radio Artists.)

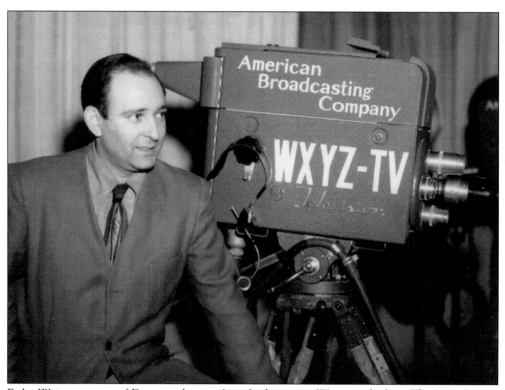

Rube Weiss was one of Detroit television's early dynamos. Weiss worked on *The Lone Ranger* and *The Green Hornet*. He also appeared as Shoutin' Shorty Hogan on Soupy Sales's late-night program *Soupy's On*, played Santa Claus in the J. L. Hudson's Thanksgiving Day parade, and was a puppeteer on WXYZ-TV's *Kookie Cat*. (Courtesy Leon Weiss.)

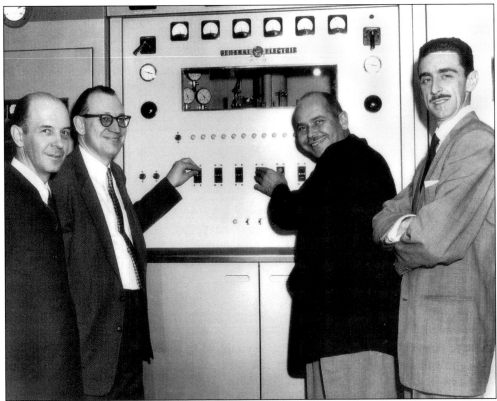

Channel 7 general manager John Pival (second from right) ran the station throughout the 1950s and 1960s. He was wild and erratic but blessed with a great eye for talent. His hires included Soupy Sales, Rita Bell, and Bill Bonds. John Lee (far right) served as program manager and executed Pival's ideas. (Courtesy WXYZ-TV.)

Marv Welch and Janie Palmer are pictured in 1952 rehearsing for Channel 4's *Musically Speaking* program. New Era potato chips sponsored the show. Welch left a year later to join WXYZ-TV as Wixie the Pixie on *Wixie's Wonderland*. (Courtesy Walter P. Reuther Library, Wayne State University.)

Professor John Sullivan (left) chats with Maxine Norquist on Channel 56's *Pre-Schooler*. Norquist hosted the show, which ran during the spring of 1957. Sullivan was chairman of Wayne State's educational psychology department. (Courtesy Walter P. Reuther Library, Wayne State University.)

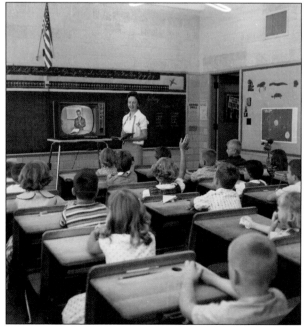

This is an example of television at work in the classroom. Donna Cornish is seen in September 1961 teaching at Everett Elementary School, located on Detroit's west side. (Courtesy Walter P. Reuther Library, Wayne State University.)

Narrator C. E. Jorgenson waits for his next cue during a presentation of Mark Twain's *Huckleberry Finn* on the campus of Wayne State University for Channel 56 (WTVS-TV). (Courtesy Walter P. Reuther Library, Wayne State University.)

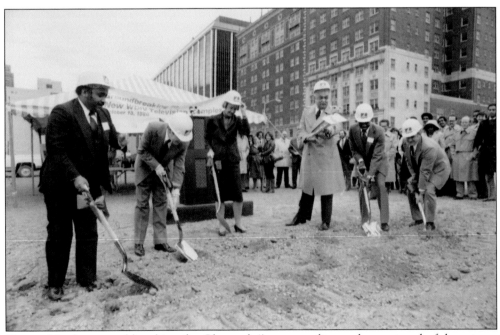

Pictured is the ground-breaking for Channel 4's new studio on the west end of downtown Detroit. Mayor Coleman A. Young is third from the right; Katherine Graham, who chaired Channel 4's owner Post-Newsweek Stations, tugs on her hard hat. Graham later wrote that the Channel 4 acquisition gave her many sleepless nights. (Courtesy Walter P. Reuther Library, Wayne State University.)

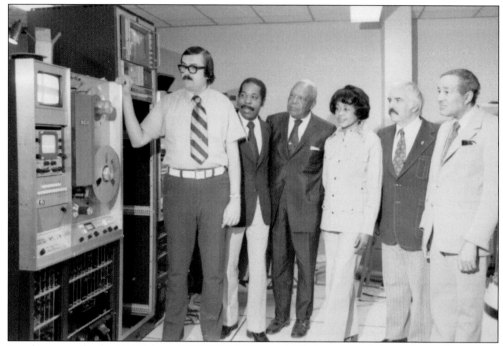

People prepare for the 1975 debut of WGPR-TV (Channel 62), the country's first African American–owned television station; the station went on the air in September. Standing in the middle (dark suit, white shirt) is Dr. William Banks, who is credited with getting the operation off the ground. (Courtesy Walter P. Reuther Library, Wayne State University.)

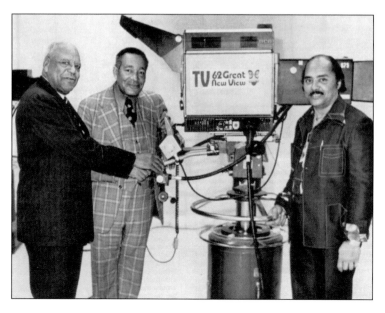

General manager Dr. William Banks (left), vice president Ulysses Boykin (center), and stage manager Nate Mackalpain of WGPR-TV check out the new equipment. (Courtesy Ed Golick.)

Two

KID'S TELEVISION

Detroit television offered a wonderful assortment of characters to the post–World War II baby boomer. From clowns and cowboys, to puppets and pirates, to a rubber-faced man who elevated pie throwing to an art form, Detroit television entertained children in a big way.

After World War II, consumers were eager to purchase items like television sets, new automobiles, and other luxury items denied them during the war. Thinking that children's shows would have enough family appeal to increase television-set sales, Philco, General Electric, and RCA sponsored WWJ-TV's first children's programming. *Junior Jamboree*, Detroit television's first children's show, was sponsored by RCA. The program did so well that it was cancelled after 18 months when the manufacturer couldn't supply enough receivers to keep up with the demand that the show was creating.

While most local stations recruited their weatherman to reluctantly don a clown suit and introduce cartoons, Detroit's television programming directors hired some of the best and brightest talent in the country to entertain the moppets of Motown. Toby David was one of the top radio voices in New York City before he dropped anchor at CKLW-TV as Captain Jolly. Irv Romig traveled the country with the Ringling Brothers Circus before being tapped by WXYZ-TV to portray Ricky the Clown. And then there was Soupy.

From 1953 to 1960, Soupy Sales was the king of Detroit television. With his able assistants White Fang, Black Tooth, and Pookie the Lion, Sales created a surreal world that kids ate up like the Silvercup bread he pitched every day on his show. When Soupy left Detroit in 1960, he forever changed the face of children's broadcasting.

Those who grew up in Detroit from the late 1940s to the early 1970s will surely enjoy this short trip down memory lane. And those too young to recall Detroit's local children's television shows will get a taste of what that magical time was all about.

Master puppeteer Ed Johnson created *Let's See Willy Dooit*, one of Detroit's first children's television shows. WWJ-TV's resident weatherman and go-to-guy, Sonny Eliot, was the voice of Willy, and Toby David, a few years away from his stint as Captain Jolly, voiced other incidental characters. The show eventually became a regular feature of *Milky's Movie Party*. When Willy wore out his welcome, Johnson took the puppets on the road, performing at hundreds of elementary school assemblies across the state. (Courtesy Greg Johnson.)

That is Mary Melody on the right (Eleanor McRobbie), around 1954, rehearsing with fellow cast members for Channel 4's *Playschool*. (Courtesy Walter P. Reuther Library, Wayne State University.)

Ardis Kenealy began her career as a model in Cypress Gardens, Florida, where she promoted the virtues of good health and outdoor living. She hit big on Detroit television as the Blue Fairy from *Playschool*, WWJ-TV's morning preschool show. (Courtesy Walter P. Reuther Library, Wayne State University.)

After Kenealy played the Blue Fairy, she went on to her best-known role as Miss Ardis, the host of WWJ-TV's *The Romper Room*. Kenealy was also a WXYZ weather girl and appeared in hundreds of commercials and industrial films. (Courtesy Ardis Kenealy.)

The program *12 O' Clock Comics*, featuring Soupy Sales, made its television debut in early 1953. Within weeks the show took off, making Soupy the hottest thing in town since sliced Silvercup Bread. The concept was simple: run a couple of cartoons and show Soupy eating his lunch. Soon every kid in Detroit wanted to eat the same thing that their pal Soupy was munching on, which the show's food sponsors loved. (Courtesy Ed Golick.)

Clyde Adler was Soupy's right-paw man, playing White Fang, Black Tooth, Pookie the Lion, Hippy the Hippo, and the man at the door. Clyde was a floor manager on the show until the fateful day that somebody lost the sound-effects record that they used for White Fang's voice. The show was live and Clyde was a team player, so off the cuff he let out a guttural growl as White Fang's voice. (Courtesy Jane Adler.)

Initially White Fang was never seen on screen, but a short time after the missing record incident one of the stagehand's wives gave Clyde a white, hairy puppet paw that she made from an old coat. He was instructed, "Don't show it to Soupy. Just put it on camera when you do the voice." Clyde did as he was told, and Soupy loved it, so the rest was history. (Courtesy Jane Adler.)

For a couple of coins and a United Dairies milk cap, people could join the Birdbath Club, Soupy Sales's official fan club. The fan-club kit included a Soupy Sales Magic Slate, a pinback button, and a membership card, which entitled the holder to attend special Soupy events held around town. When Sales hosted movies for club members at downtown Detroit's Fox Theatre, it was always filled to capacity with hundreds of fans spilling onto Woodward Avenue. (Courtesy Tom DeWitt.)

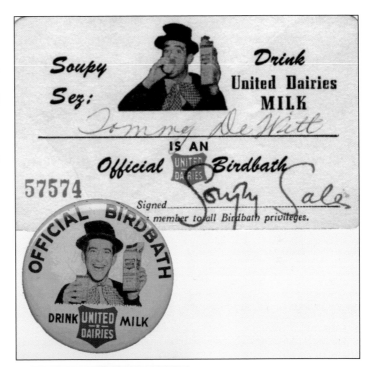

In 1950, Clare Cummings hosted *Peter, Clare, and Oscar.* Peter was a live rabbit, Clare was the straight man, and Oscar was a puppet. The show only lasted for 13 weeks on Channel 2. (Courtesy Peggy Tibbits.)

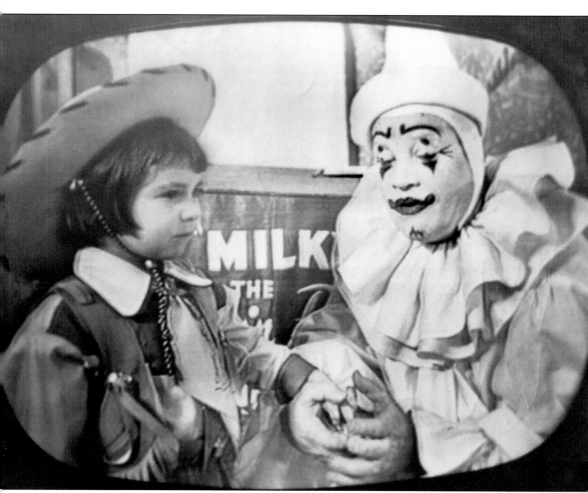

However, the station's bigwigs were so impressed with Clare Cumming's gentle manner and engaging gap-toothed smile that they chose him to host their new kid's show, *Milky's Movie Party*. Ask any Detroiter over the age of 50 what Milky's magic word was, and the response will be a resounding "Twin Pines!" (Courtesy Peggy Tibbits.)

In 1963, when Clare Cummings decided to devote more time to his day job as a DuPont paint salesman, he called on his good friend Karrell Fox to take over as the Twin Pines magic clown. Fox, no stranger to Detroit television, was a regular on *Junior Jamboree*, Detroit television's first children's show. Fox gained a reputation among magic professionals as one of the country's finest comic magicians, creating hundreds of tricks and patter routines. (Courtesy Ed Golick.)

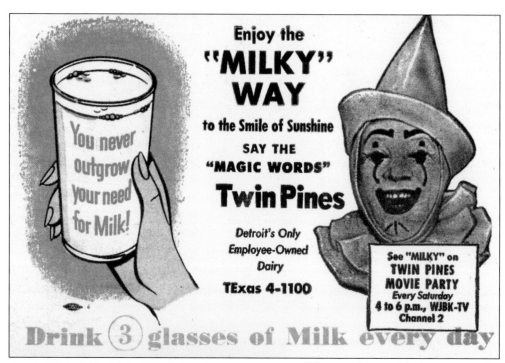

Who can forget Milky's magic words, "Twin Pines," and TE4-1100, the phone number for Twin Pines Dairy, which was repeated multiple times by the Twin Pines Milkman on each show. (Courtesy Ed Golick.)

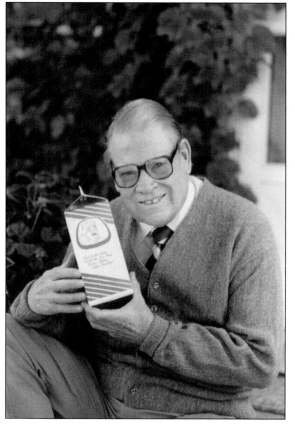

Cummings is pictured in later years checking out a Twin Pines milk carton. He died in 1994, at the age of 82. (Courtesy Peggy Tibbits.)

Ralph Binge, the second banana of the legendary radio team of Binge and Gentile, played pirate Pete. From 1954 to 1956 the beefy buccaneer and his parrot, Mr. Bones, sailed the waters of the Great Lakes searching for adventure while showing Crusader Rabbit cartoons. (Courtesy Ed Golick.)

The character Auntie Dee was played by Dee Parker, a diminutive female singer who toured the country with Jimmy Dorsey's big band. While singing at the Brass Rail in downtown Detroit, Parker was discovered by WXYZ-TV's head of programming, Pete Strand. *The Auntie Dee Show* was the *America's Got Talent* for Detroit youngsters. The show's musical director was Uncle Jimmie Stevenson, who was billed as "the man with the educated eyebrows." Stevenson would rehearse the acts in the basement of the Maccabees Building before showtime, accompanying them on a piano. The show was not a contest, since winners were not declared and prizes were not awarded, although each participant received a six-pack of Faygo Pop, courtesy of the show's sponsor. (Courtesy Ed Golick.)

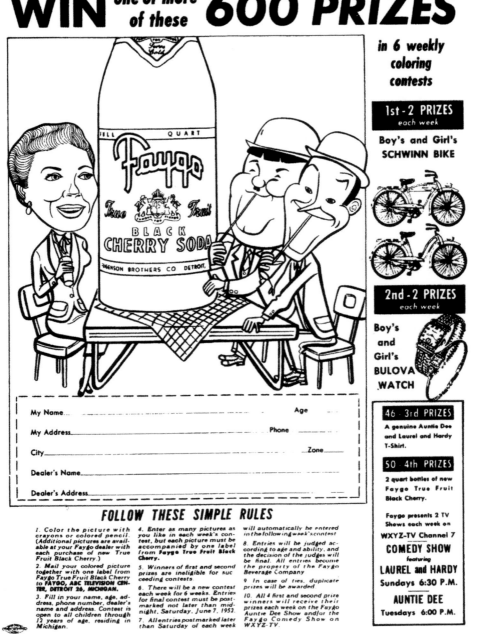

Local stations used contests to judge a program's popularity. WXYZ combined two popular programs, *The Auntie Dee Show* and *Laurel and Hardy*, for a big Schwinn bike giveaway. Faygo sponsored both programs and remains a Detroit institution to this day. (Courtesy Ed Golick.)

Nightclub comedian Marv Welch played Wixie on *Wixie's Wonderland* from 1953 to 1957. Assisting Wixie on the show was piano player Diane Dale; Gee-Whiz the Clown, played by artist Ken Muse; and loveable Gramps, played by Frank Nastasi. Welch often partied into the early hours of the morning but was bright eyed and bushy tailed at 7:00 a.m. when the show started. (Courtesy Ed Golick.)

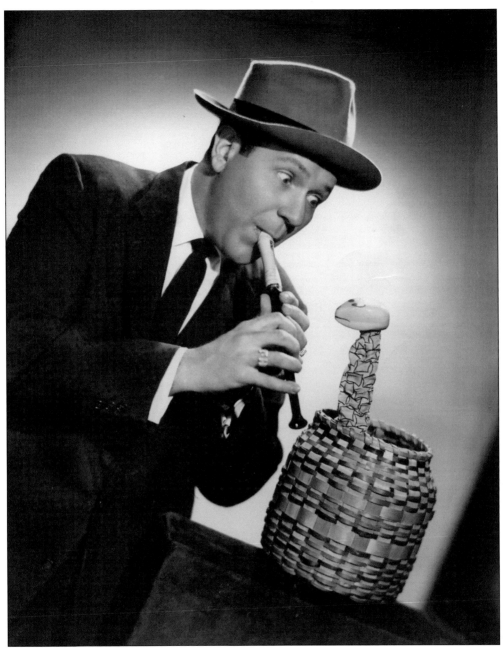

Another nightclub comic turned children's television entertainer was Harry Jarkey. The WXYZ-TV station manager thought that Jarkey would be the perfect host for a morning talk show. *Our Friend Harry* was a hodgepodge of music, news, interviews, human-interest stories, and film. (Courtesy Harry Jarkey.)

In 1959, Jarkey hosted *Fun House*, a Saturday morning kid's game show. Ricky the Clown assisted with the games and prizes, and Polka virtuoso Stan "Stosh" Wisniach supplied the music along with Jimmie Stevenson, who worked as Auntie Dee's musical director. (Courtesy Harry Jarkey.)

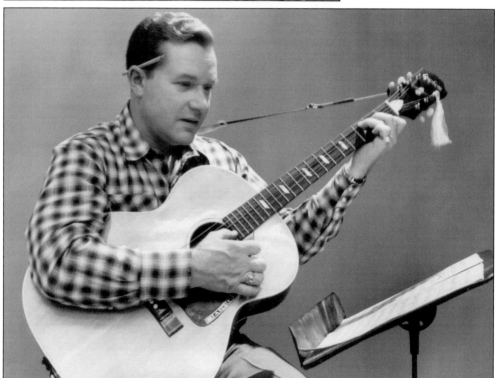

Ted Lloyd created the Sagebrush Shorty character in 1949 for KGIL Radio in Los Angeles. Shorty made it to San Antonio television before coming to Detroit's WJBK-TV in 1955. Sage's ventriloquial sidekick Skinny Dugan was a mechanical marvel, equipped with 10 different facial and head movements. He could wiggle his ears and nose, spit, cry, wink, stick out his tongue, roll and cross his eyes, flip his hair up and down, and have his nose glow bright red. Most of these movements were controlled by a complicated series of cables and levers resembling typewriter keys that were attached to the dummy's control stick. (Courtesy Ed Golick.)

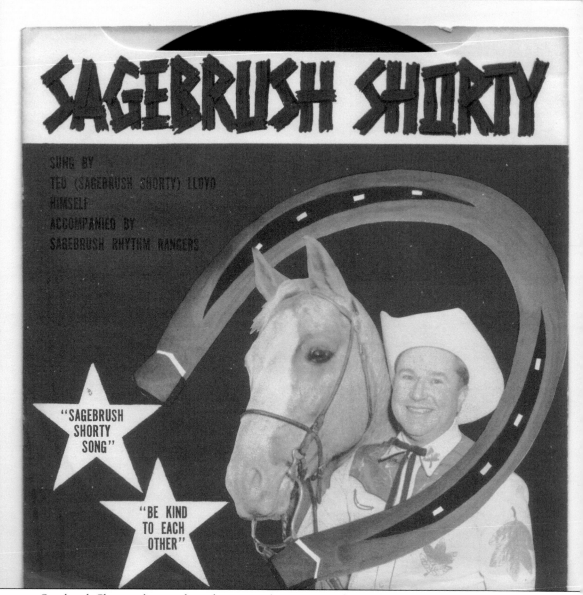

Sagebrush Shorty, along with working as a television star, also made a 45-rpm recording. For 57¢, people could buy the *Sagebrush Shorty Theme* at a local record store. Snooper, Sagebrush's horse, is sharing the record cover with him. Sagebrush's band, the Rhythm Rangers, provided backup. (Courtesy Ed Golick.)

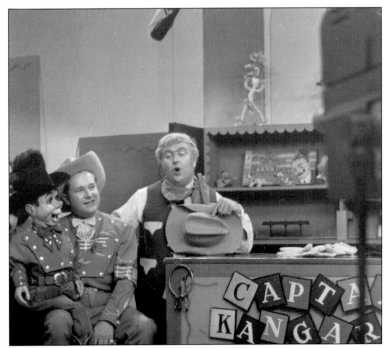

Sagebrush Shorty appeared with Captain Kangaroo on June 6, 1959. The Captain decorated the Treasure House in Western mode just for the occasion. (Courtesy Ed Golick.)

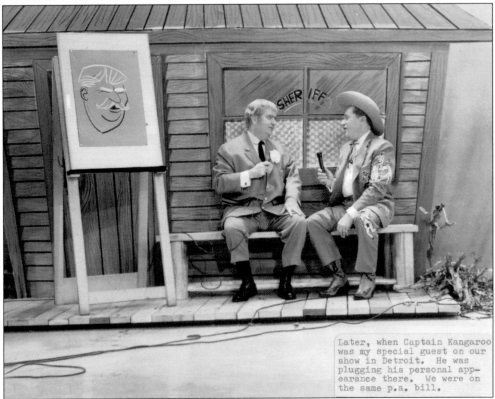

Later, when Captain Kangaroo was my special guest on our show in Detroit. He was plugging his personal appearance there. We were on the same p.a. bill.

Later that year, the Captain returned the favor by appearing on Sagebrush Shorty's show in Detroit. (Courtesy Ed Golick.)

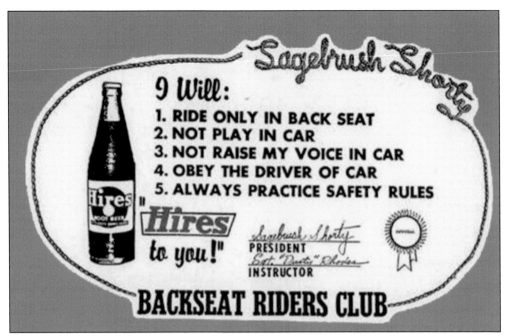

WJBK gave away thousands of Backsest Riders Club decals to Sage's fans courtesy of Hires Root Beer, the "drink of happiness." (Courtesy Ed Golick.)

Lloyd was fired from WJBK in 1960 when he filed suit against Storer Broadcasting for a chimpanzee bite that his wife received while wrangling kids behind the scenes on the show. Two years later, Lloyd returned to Detroit television on WXYZ's *Sagebrush Shorty's Fun Ranch*. Lloyd left Detroit in 1964 and returned to Los Angeles where he performed at kid's parties and worked as a part-time bartender until his death in 1999. (Courtesy Ed Golick.)

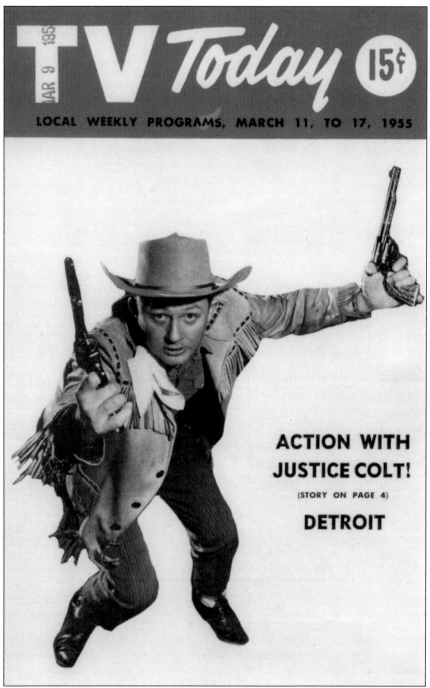

TV *Today* 15¢

MAR 9 195

LOCAL WEEKLY PROGRAMS, MARCH 11, TO 17, 1955

**ACTION WITH
JUSTICE COLT!**

(STORY ON PAGE 4)

DETROIT

J. D. Beemer had some big boots to fill. His father was Brace Beemer, WXYZ radio's *The Lone Ranger*. Born on a farm not far from the Kentucky border, J. D. broke and trained his first horse at age 12. An interest in dramatics led him to television, and in 1950 he hosted old Lash LaRue films on WXYZ-TV as Justice Colt. Beemer eventually left television, earned a degree in criminal psychology at Oakland University, and became a parole officer in Virginia before his death in 1989. (Courtesy Sheri Beemer.)

Ricky the Clown's circus antics entertained Detroit kids on WXYZ-TV for 12 years, but professional clown Irv Romig had been working under the big top since the age of five. Romig's parents worked with the Ringling Brothers and eventually traveled the Midwest with the Romig and Rooney Circus. On television, Ricky was known for his menagerie of live animals, which he transported to the studio every day, and his songs that were sung in the style of Al Jolson. (Courtesy Ed Golick.)

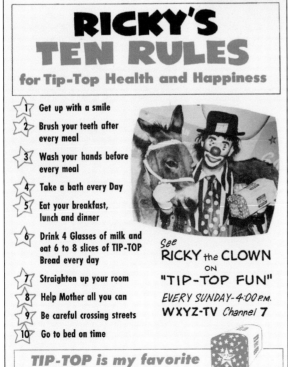

RICKY'S TEN RULES
for Tip-Top Health and Happiness

1. Get up with a smile
2. Brush your teeth after every meal
3. Wash your hands before every meal
4. Take a bath every Day
5. Eat your breakfast, lunch and dinner
6. Drink 4 Glasses of milk and eat 6 to 8 slices of TIP-TOP Bread every day
7. Straighten up your room
8. Help Mother all you can
9. Be careful crossing streets
10. Go to bed on time

see RICKY the CLOWN ON "TIP-TOP FUN" EVERY SUNDAY-4:00 P.M. WXYZ-TV *Channel* 7

TIP-TOP is my favorite

Ricky's first television show was called *Tip Top Fun*, sponsored by Tip-Top Bread. After a few months on the air, the FCC insisted that WXYZ change the name of the show because the sponsor's name was not allowed in the title. Most of Ricky's Rules still apply today, but even Irv Romig shudders when he reads rule six: eat eight slices of white bread every day. (Courtesy Irv Romig.)

In Detroit, all of the girls had a crush on Johnny Ginger, while all of the boys wanted to be Johnny Ginger. Born Galen Grindle, Ginger was part of the family vaudeville act, playing on the bill at Toledo's Paramount Theater with the Three Stooges. Ginger later went solo, working at nightclubs in Toledo and Detroit as Jerry Gale when WXYZ-TV's head of programming, Pete Strand, hired the young comic to host Three Stooges shorts on *Curtain Time Theater.* Ginger's comedy bits became so popular that they edited the shorts to allow more time for the bits. (Courtesy Johnny Ginger.)

Ginger became friends with Moe Howard, Larry Fine, and Joe DeRita when he appeared with them in The Three Stooges's last theatrical film, *The Outlaws Is Coming.* The film featured a great gimmick: the outlaws were played by some of the most popular kiddie television hosts in the country who aired the old Columbia Three Stooges shorts. Ginger portrayed Billy the Kid in the film. (Courtesy Ed Golick.)

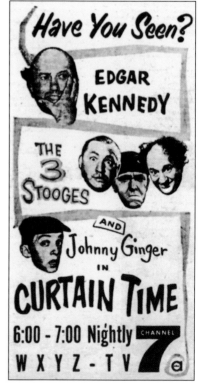

Captain Jolly, played by Toby David, introduced the classic Max Fleischer *Popeye* cartoons to a generation of Detroit kids. David started at CKLW-AM in 1935 as part of the *Happy Joe and the Early Morning Frolic* radio program with Ralph Binge. He then left Detroit for Washington D.C. and New York City, eventually returning to Detroit in 1946. He created the Captain Jolly character for *Popeye and Pals* at CKLW-TV (Channel 9) in 1958. David also did the morning drive show at CKLW-AM, was president of the Adcraft Club, and worked tirelessly for nearly every local children's charity. (Courtesy Ron David.)

Toby David made many personal appearances as Captain Jolly. At downtown Detroit's Fox Theatre, David filled the house. Note the bottom of the Fox marquee announcing a concert with four up-and-coming lads from Liverpool, England. (Courtesy Ron David.)

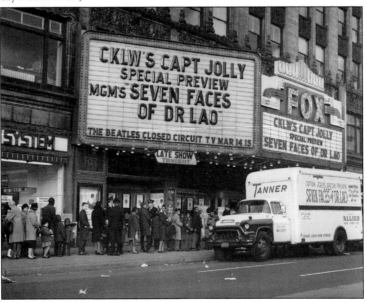

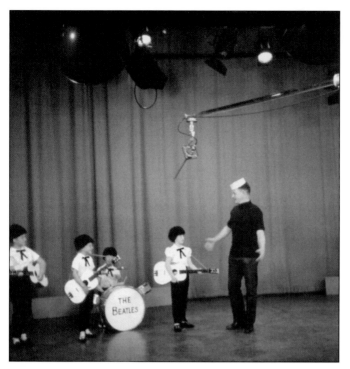

Captain Jolly may have kept things shipshape during the week, but the weekends belonged to Poopdeck Paul. With his trademark form-fitting black shirt and U.S. Navy sailor hat, Paul Schultz had his finger planted firmly on the pulse of Detroit's youngsters. When the Beatles were red hot, Schultz emceed Beatles lip-synching contests. When the limbo was the rage, Schultz imported limbo champions to show how it was done. Schultz opened up the CKLW studio doors and held relay races on the front lawn along Riverside Drive and go-cart races in the studio parking lot. (Courtesy Cynthia Zwick.)

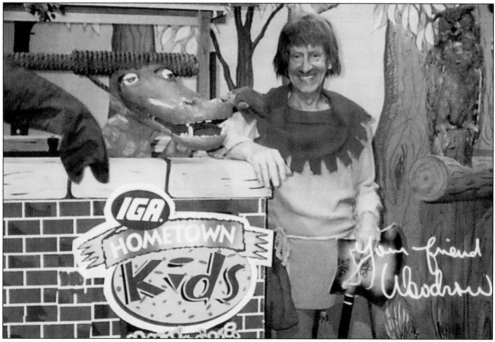

Woodrow the Woodsman first aired on WKYC in Cleveland, but when the station was sold in 1965, Clay Conroy uprooted the "Enchanted Forest" and replanted it at WJBK-TV. (Courtesy Ed Golick.)

Hope you watch
me every morning
at 7.

Your friend
Woodrow

TV2
WJBK◉TV

Woodrow's puppet pals Tarkington Whom III the Owl, Voracious the Elephant, and Freddie the Alley-Croc were all played by Lawson Deming, better known as Detroit's beloved vampire movie host Sir Graves Ghastly. When the show was cancelled in 1970, Conroy returned to Cleveland television, where a couple of different versions of the show aired until his death in 2003. (Courtesy Ed Golick.)

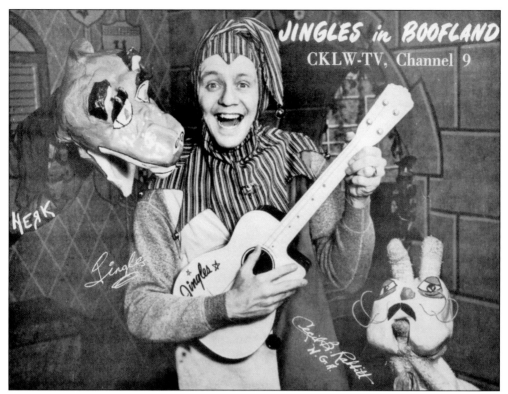

Jingles in Boofland started life as *Fun and Stuff* at WPTA-TV in Fort Wayne, Indiana. In 1958, Jerry Booth and his writing partner Larry Sands brought the show to CKLW-TV. Booth played Jingles the Jester, but the genius behind the show was Sands. The multitalented writer composed the show's theme song, wrote scripts, voiced the puppets, and occasionally appeared on air. Jingles's puppet pals were Herkimer the Dragon and Cecil B. Rabbit (world's greatest authority)—who parodied newsman Paul Harvey. (Courtesy Ed Golick.)

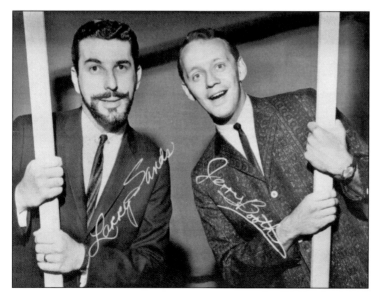

When CKLW dropped Jingles in 1963, Larry Sands created *The Larry and Jerry Show*, a free-form half hour with his pal Jerry Booth, featuring contests and crazy characters like Grbtz, an artist who always painted the same picture, and an ornithologist whose birdcalls suspiciously all sounded the same, "Twaa! Twaa!" (Courtesy Ed Golick.)

Larry Sands was fired in 1965 by a new program director who felt that the station was paying him too much. Sands saw the handwriting on the wall and left Detroit for the advertising game in Chicago, leaving his television partner behind. Booth bounced back with a new show, *Jerry Booth's Fun House*, which introduced Detroiters to Astro Boy and the Marvel superheroes cartoons. Hanging on the Fun House wall was Booth's sidekick, a mounted moose head named Clyde Casual. The only thing Clyde ever said was "uh-huh," but one Thanksgiving he urged viewers to "wrap your head in aluminum foil." Booth left Detroit in 1968 for the West Coast, where he works in sales. In 1974, Sands was killed in a helicopter crash while shooting a television commercial in California. (Courtesy Ed Golick.)

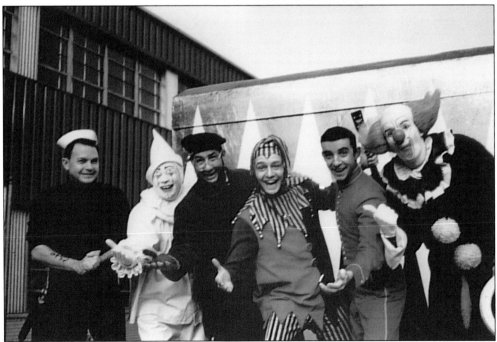

It was a surefire bet that favorite kid-show hosts would participate in Hudson's Thanksgiving Parade. In this c. 1961 picture are, from left to right, Poopdeck Paul, Milky the Clown, Captain Jolly, Jingles, Johnny Ginger, and Bozo the Clown. (Courtesy Peggy Tibbits; Bozo the Clown is a registered trademark of Larry Harmon Pictures Corporation.)

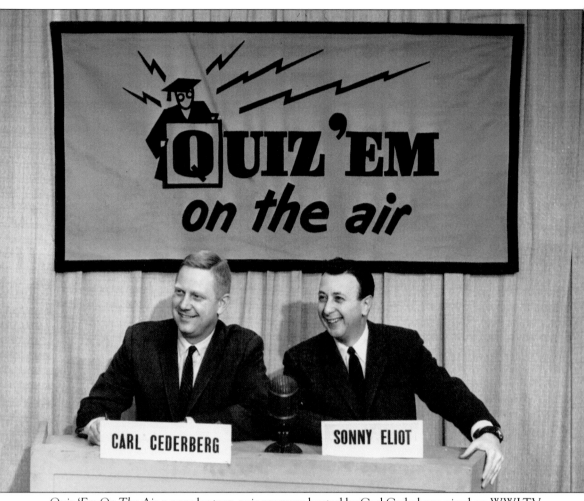

Quiz 'Em On The Air, a popular teen quiz program hosted by Carl Cederberg, aired on WWJ-TV (Channel 4) from 1954 through the 1960s. Public, private, and parochial schools throughout the Detroit area answered questions based on current events in the *Detroit News*. Each show featured a special guest, usually a local sports, news, or media personality, who assisted Cederberg with the questions. Prizes were donated to the winning team's schools. *Quiz 'Em On The Air* was originally conceived as a way to combat juvenile delinquency in Detroit. (Courtesy Sonny Eliot.)

In 1946, Capitol Records producer Alan Livingston created a series of records packaged with a read-along storybook with a character he called Bozo the Clown. In the late 1950s, entrepreneur Larry Harmon purchased the licensing rights to the character and created local Bozo shows in every major market. In Detroit, Bozo was played by Bob McNea, a Canadian actor who had previous experience on CKLW-TV as Moppets the Clown. The Bozo show was broadcast live, six days a week, and was the first Detroit children's show to be broadcast in color. (Courtesy Ed Golick; Bozo the Clown is a registered trademark of Larry Harmon Pictures Corporation.)

In 1967, WWJ-TV decided that they would drop the Bozo franchise, allowing McNea to create a new character, Oopsy Daisy. For weeks, as Bozo, McNea told the kiddies that the big top was moving to another city but his cousin Oopsy would be taking his place. The transition from Bozo to Oopsy went off without a hitch. Bob Elnicky created Oopsy's puppet friends, Henrietta Peck, Squiggly Wiggly Worm, and Miser Mouse. In the next decade, Elnicky created the puppets for another popular kids television show, *Hot Fudge*. (Courtesy Kathy McNea.)

CKLW-TV picked up the Bozo franchise in 1967. When the casting call went out, nearly every actor in Detroit submitted an audition tape. Art Cervi—who wrangled teenagers and booked talent for *Swingin' Time*, CKLW's teen music show—was convinced to submit a tape. Although he had the least on-air experience of all the candidates, his tape was chosen as the best one. Cervi was given a 30-day trial, which lasted until 1975. WJBK-TV picked up the show for another five years until 1980, when Bozo's size 47 shoes were shown the door. (Courtesy Art Cervi; Bozo the Clown is a registered trademark of Larry Harmon Pictures Corporation.)

In the 1960s, *Romper Room* aired on CKLW-TV with Flora Paulin as hostess. Paulin sang light opera in Windsor, Ontario, which more than qualified her to sing the Romper Room "Do Bee" song. (Courtesy Matt Keelan.)

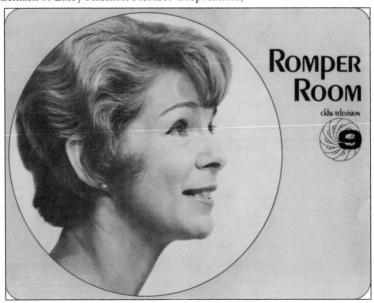

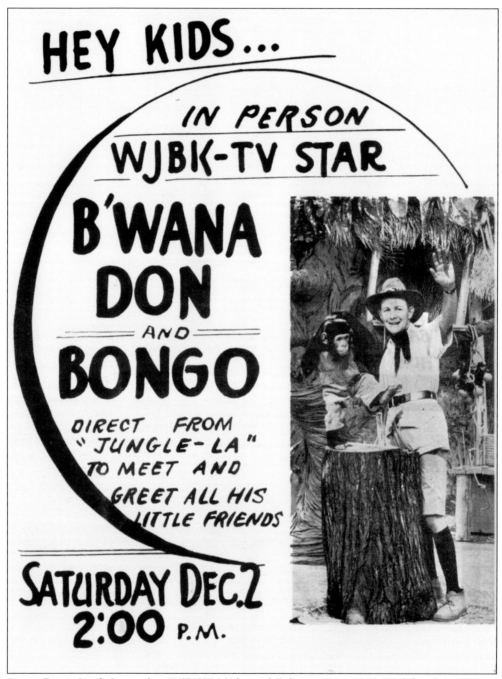

HEY KIDS...

IN PERSON
WJBK-TV STAR

B'WANA
DON
— AND —
BONGO

DIRECT FROM
"JUNGLE-LA"
TO MEET AND
GREET ALL HIS
LITTLE FRIENDS

SATURDAY DEC. 2
2:00 P.M.

Bwana Don in Jungle-La aired on WJBK-TV (Channel 2) from 1960 to 1963. With his chimp Bongo Bailey, Don Hunt hosted cartoons while teaching Detroit's small children about the wonders of the animal kingdom. In the summer of 1961, Hunt took a movie camera to Kenya to film animal footage for the show. He loved the area so much that he moved there permanently in 1964. With his wife, Iris, Hunt manages the Mount Kenya Game Ranch, a sanctuary for dozens of species of wild animals. Through his reserve, Hunt has saved the white zebra and the mountain bongo from extinction. (Courtesy Ed Golick.)

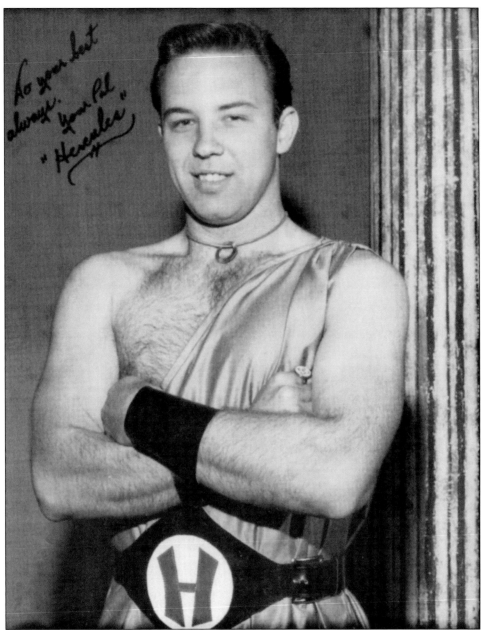

Don Kolke hosted a 15-minute news show on Detroit Educational Television before donning a toga to portray Hercules on CKLW-TV. Kolke promoted physical fitness and told stories of Greek mythology while showing *Hercules* cartoons. Hercules was probably Detroit's first (and only) minimalist television show. The set was comprised of a couple Greek columns in front of a sky drop. Hercules's sidekick, Newton the Centaur, was never seen on screen. The show's budget would not allow for a proper puppet, so the floor manager waved a tree branch in front of the camera to suggest that Newton was camera shy and could not appear on air. The last episode aired on December 19, 1964, when Hercules announced that he was leaving the show to marry "the most beautiful girl in the world, Judy Sullivan." Kolke is still married to his beautiful girl. (Courtesy Don Kolke.)

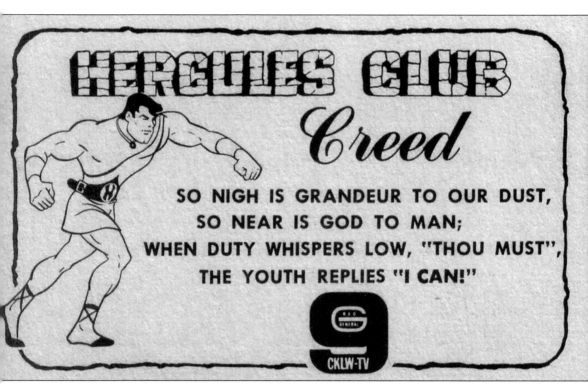

Here is the Hercules creed, courtesy of Ralph Waldo Emerson. (Courtesy Don Kolke.)

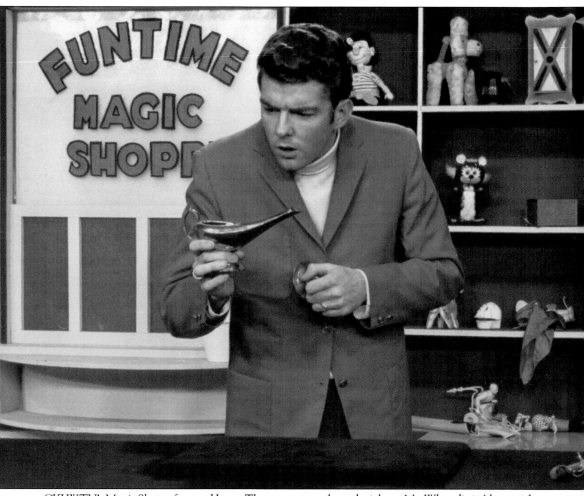

CKLW-TV's *Magic Shoppe* featured Larry Thompson as turbaned trickster Mr. Whoodini. Along with his sidekick Sam Snake, "the smartest snake in the world," Thompson performed tabletop and close-up magic. Amateur magic sets were given away as prizes on the show. (Courtesy Matt Keelan.)

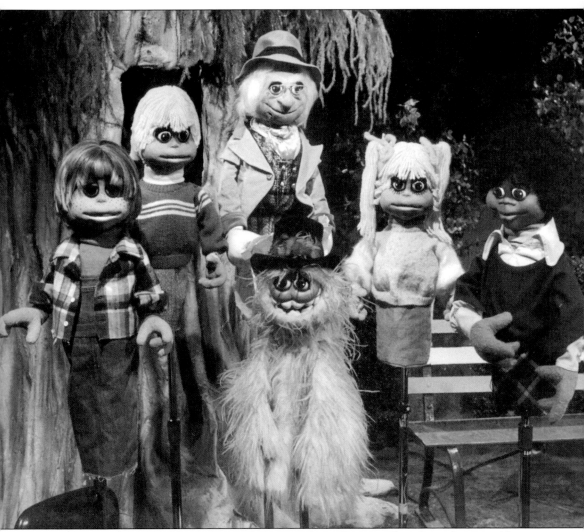

Hot Fudge was produced by WXYZ-TV between 1974 and 1980 and syndicated in over 90 cities nationwide until 1980. The puppets were Seymour, Glen Denver, Mona, the Kaz, and others. Humans on the show included Arte Johnson, Ron Coden, Larry Santos, and Yo Williams. The most popular feature was "Name That Feeling," a game show parody hosted by Professor Emotion, who drew out the feelings of the puppet characters. (Courtesy WXYZ-TV.)

Three

NEWS

News has gone from an afterthought to the sole daily local offering on most Detroit television stations. Channel 7 offered as little as five minutes a day of news in the late 1950s. Channels 2 and 4 would often serve up 45 minutes or so. Now Channels 2, 4, and 7 often broadcast five hours or more of daily news.

Channel 4 (WWJ-TV) dominated local television news from the medium's birth until the 1960s. It had the largest broadcast newsroom in the state and the promotional and financial backing of its owner, the Evening News Association, which also owned the *Detroit News*—Michigan's biggest newspaper. The arrangement gave each party a huge promotional advantage over its competitors.

However, that dominance melted away when Channel 2 (WJBK-TV) and Channel 7 (WXYZ-TV) became more serious about news. At the beginning of the 1960s, a typical Channel 2 newscast was put together by as few as three people—the anchorman, a producer, and a photographer. By the mid-1960s, Channel 2 had assembled the wildly popular news team of Jac Le Goff, John Kelly, Jerry Hodak, and Van Patrick. They injected occasional banter into the news, giving it personality, and viewers responded.

Channel 7 (WXYZ-TV) did not jump into news until the mid-1960s; the station aired as little as five minutes of daily news in the 1950s. By the mid-1960s, the American Broadcasting Company, Channel 7's owner, decreed that the station would get serious about journalism.

The 1967 Detroit riot changed the nature of television journalism. Viewers watched the city burn. Channel 7's Bill Bonds distinguished himself during the riot, and by the time the flames were extinguished and the smoke cleared Channel 7 had proven itself a force in the business.

A nine-month newspaper strike at the *Detroit News* and the *Detroit Free Press* in 1967–1968 removed a main source of information in a watershed year of news. The city was dealing with the aftermath of the 1967 riot and two political assassinations (Martin Luther King Jr. and Robert F. Kennedy), and local television was the chief source of information for many Detroiters. That has not changed to this day.

Channel 4's Paul Williams sits at the anchor desk in September 1953; note the simplicity of the set. Is there any question as to which company sponsored the newscast? (Courtesy Walter P. Reuther Library, Wayne State University.)

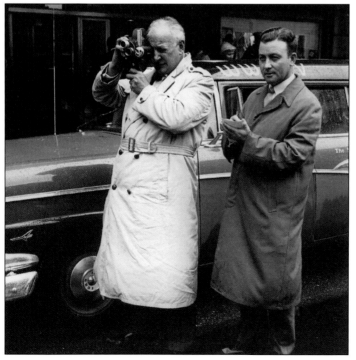

Have trench coat, will report—photographer Hank Shurmur (left) and reporter Ven Marshall are pictured on the job in the mid-1950s. Both men had legendary contacts in the business. Anchorman Bill Bonds once said of Marshall, "If he had been covering the *Titanic*, Ven would have a guy on the iceberg, waiting to call when it happened." (Courtesy WDIV-TV.)

Channel 4's Hank Shurmur is watching the world. The station's news department subcontracted its photography work to Shurmur's company. The "We Never Sleep" news agency shot every foot of film for the station's newscast until the early 1970s. (Courtesy Walter P. Reuther Library, Wayne State University.)

Legendary photographer "Snuffy" McGill (with cigar) is working his camera. Like many early television news cameramen, he learned his craft as a World War II combat photographer. He shot for ABC, CBS, Channel 2, and *Hearst Metrotone News* among others. McGill and his wife, Edythe, later built Snuffy McGill Productions, a successful motion picture public relations firm. (Courtesy Sue A. McGill.)

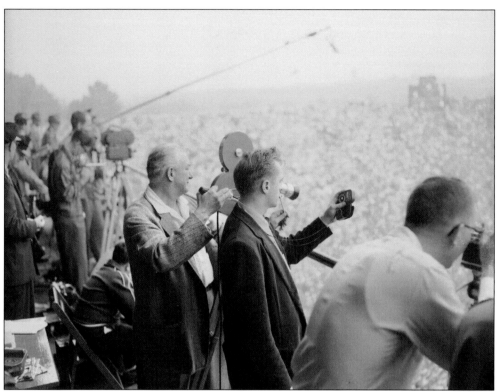

A crew is filming the University of Michigan versus Michigan State University football game on October 6, 1956. Michigan State won by a score of 9 to 0 in front of 101,001 fans—the biggest crowd of the season that year in Ann Arbor. (Courtesy Walter P. Reuther Library, Wayne State University.)

Austin Grant began his career in radio at WWJ-AM in the 1930s and stayed at Channel 9 until he left in 1965. His trademark sign-off was, "That'll be all . . . from Austin Grant." (Courtesy WDIV-TV.)

"It's 11 o' clock. Do you know where your children are?" rang the voice of Channel 2's Bob McBride, who worked at the station as a news director, public affairs chief, and general manager. He delivered the station's editorial, tagging them all with the phrase, "What do *you* think?" (Courtesy the *Detroit Free Press*.)

Sonny Eliot's broadcasting career spans the mid-1940s to the present day at WWJ-AM. Eliot smiles next to the weather chart in the early 1950s. He worked as a pilot during World War II and spent 17 months in a prisoner-of-war camp. (Courtesy Sonny Eliot.)

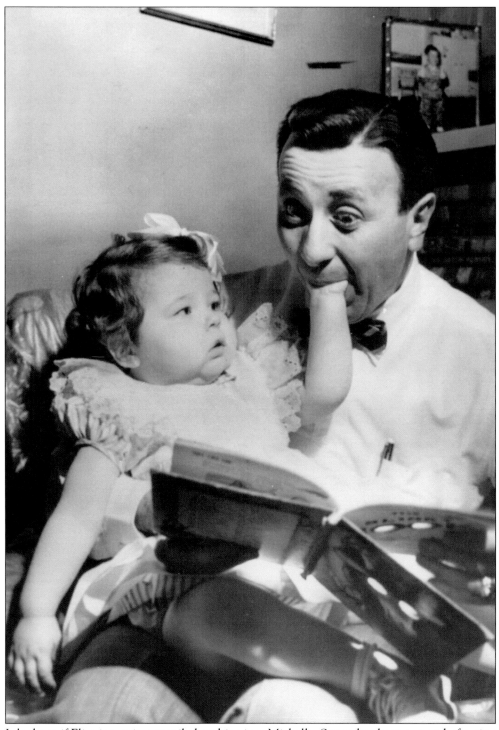

It looks as if Eliot is turning cannibal on his niece Michelle. Sonny has been accused of eating scenery, however, this takes the phrase to completely different level. (Courtesy Sonny Eliot.)

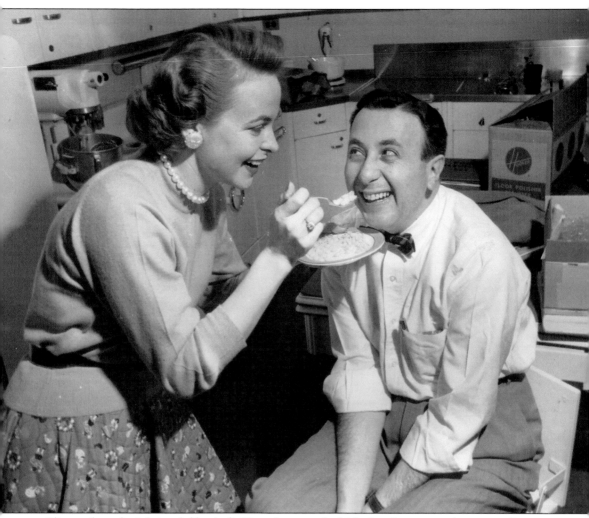

Eliot smiles as he is being fed by Ardis Kenealy, a popular kid's show hostess on the station. Being the station's top draw has its advantages. (Courtesy Sonny Eliot.)

Eliot points to the weather board in the mid-1950s. Notice the lack of high-tech appliances. (Courtesy Sonny Eliot.)

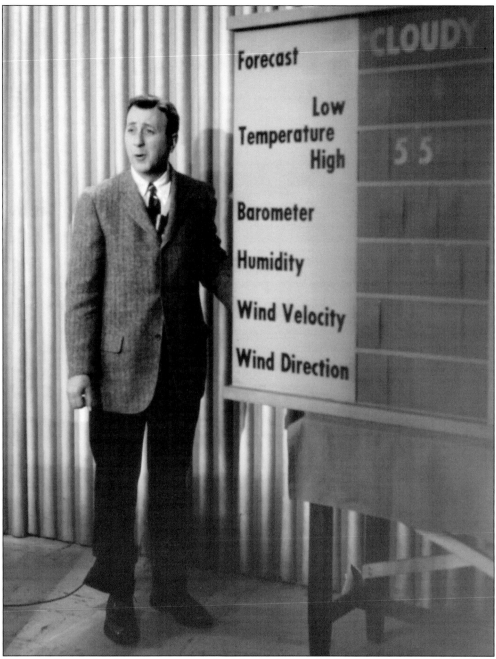

Eliot ran the weather board via a series of toggle switches in the 1950s—forecasting the weather is beginning to get a little more electric. (Courtesy Sonny Eliot.)

Here Eliot leads a group of bicyclists through downtown Detroit in 1967. (Courtesy Sonny Eliot.)

Sonny hassles anchorman Dean Miller in the mid-1970s. (Courtesy Sonny Eliot.)

Sonny and his wife, Annette, are planning their next move at the J. L. Hudson's Thanksgiving Day Parade. (Courtesy Sonny Eliot.)

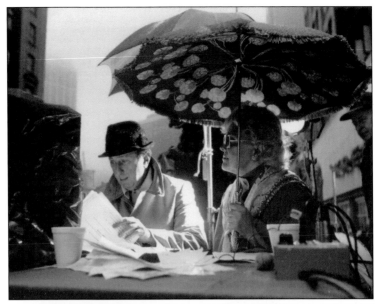

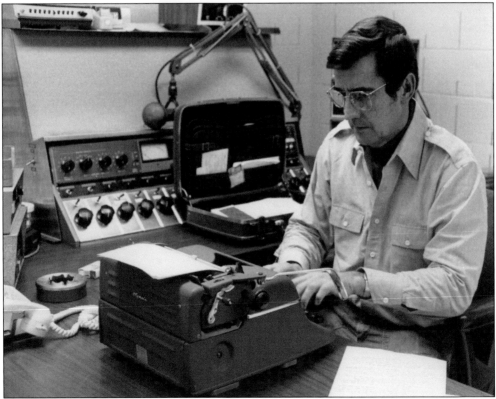

Dave Diles is pictured at the typewriter, which was his real home. Diles was known both in Detroit and nationally as a sportscaster. However, most of his colleagues say he was an even better wordsmith. He broke in at the *Associated Press* bureau in Detroit as a sportswriter, only later getting a job in television when Channel 7 general manager John Pival heard Diles's shtick at a country club roast. (Courtesy the *Detroit Free Press*.)

This is the team that made Channel 4 and WWJ-AM the preeminent broadcast news operation in town. From left to right are news director James Clark, who ran the operation, Ven Marshall, Britton Temby, Hank Shurmur, Bob Stevens, Lare Waldrop, unidentified, Dwayne X. Riley, and Paul Williams. (Courtesy Royal Music.)

Al Ackerman did the sports for two Detroit television stations, Channel 4 (twice) and Channel 7. His firing from Channel 4 for unauthorized editorializing brought an avalanche of mail. He especially liked picking on Detroit Lions owner William Clay Ford. Ackerman wondered why the hard-working folks in Pontiac paid for the Silverdome, the Detroit Lions' home, when Ford had millions. Ackerman's dyspeptic style became a template for the countless talk shows that inhabit the radio dial these days. (Courtesy the *Detroit Free Press*.)

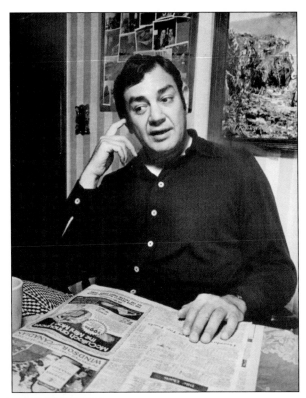

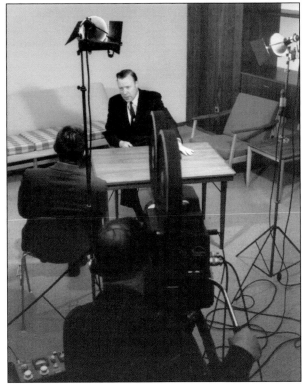

Here United Auto Workers president Walter Reuther is talking about unions. Reuther was particularly adept in front of the television camera. The union also had its own television and radio programs, hosted by Guy Nunn. (Courtesy Sue A. McGill.)

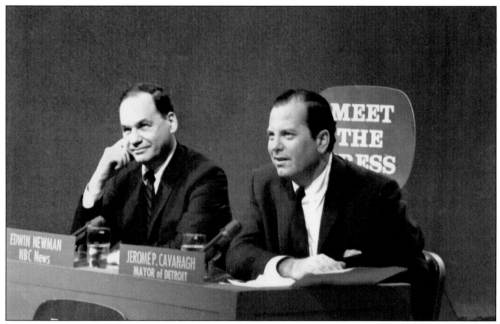

Detroit mayor Jerome P. Cavanagh and NBC News's Edwin Newman are on *Meet the Press* on July 30, 1967. The Motor City went up in flames the previous week, and 43 people died in the rioting. Pres. Lyndon Johnson sent in the U.S. Army to quell the disturbance. (Courtesy Walter P. Reuther Library, Wayne State University.)

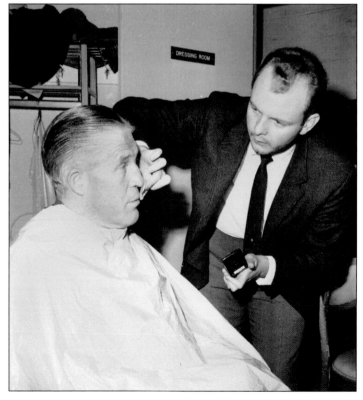

Michigan governor George Romney is preparing for his close-up on NBC's *Meet the Press*. Romney rose rapidly in the world of politics: from a delegate to the state's constitutional convention in the early 1960s, to a surprise victory over incumbent governor John B. Swainson in 1962, to another victory in 1966. With the Republican Party in shambles after the 1964 Barry Goldwater debacle, many in the party thought Romney's moderate positions would sit well with voters. (Courtesy Walter P. Reuther Library, Wayne State University.)

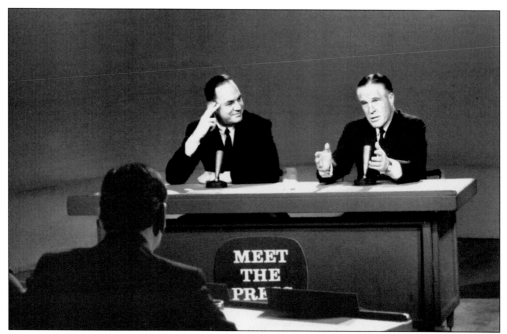

He is ready for his close-up. Romney, now in makeup, is on the NBC's *Meet the Press* set with Edwin Newman on November 2, 1966. Romney was already considered presidential timber. (Courtesy Walter P. Reuther Library, Wayne State University.)

Host Toby David could do something other than play Captain Jolly. He had extensive political connections and was appointed by then governor George Romney to the Michigan State Fair Authority. David is seen here (center) with Romney making a pitch for the 1968 Olympics, which went to Mexico City. (Courtesy WXYZ-TV.)

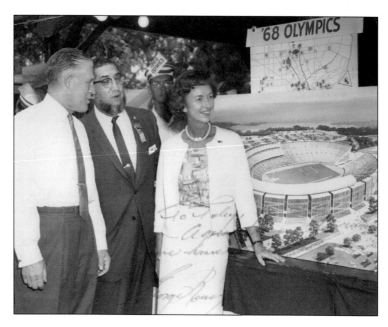

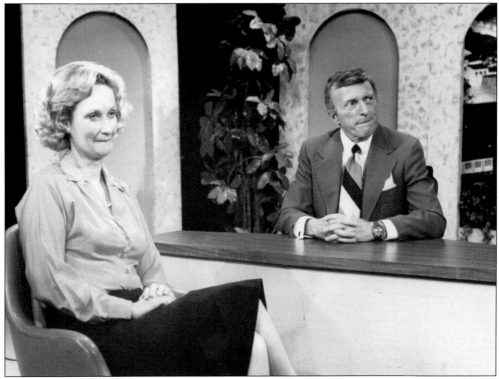

Channel 50 commentator Lou Gordon is pictured with his wife and cohost, Jackie. No target was too big for Gordon. He once questioned presidential candidate George Wallace's sanity—to his face. Michigan governor George Romney's presidential ambitions began to melt after stating that he had been "brainwashed" on a fact-finding tour of Vietnam while on Gordon's show. (Courtesy Deborah Gordon.)

Mort Crim brought Channel 4 into a new era after his arrival in 1978. The station was down in the ratings when Post-Newsweek Stations acquired the station from the Evening News Association. Crim was Post-Newsweek's first major on-air hire. It took years for Motor City viewers to believe that Crim was a real Detroiter. Crim eventually became one of the city's most beloved public figures. (Courtesy the *Detroit Free Press*.)

Channel 7 anchorman Leon McNew (left) is checking out wire copy with Dave Diles. McNew once played Captain Flint on a show by the same name, but despite his lack of a journalism background he was tapped to anchor the news. He was later replaced by Bill Bonds. Diles, a former *Associated Press* reporter, was said to be one of the best writers in town. (Courtesy WXYZ-TV.)

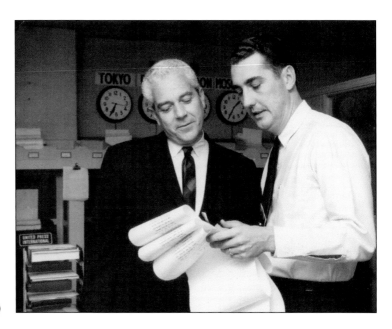

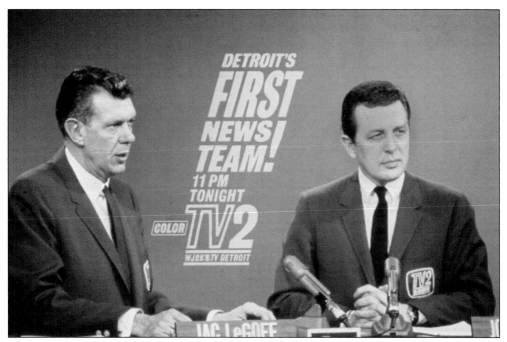

Channel 2's Jac LeGoff (left) and John Kelly (right) led the ratings in the mid- and late 1960s. The two were the Chet Huntley and David Brinkley of Detroit television—with ratings to match. Both jumped to Channel 7 within a few years. (Courtesy WJBK-TV.)

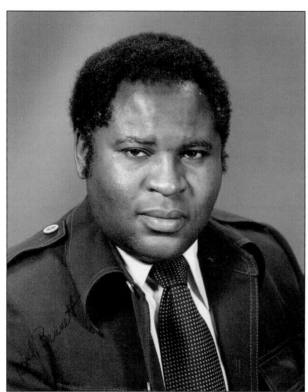

Bob Bennett had extraordinary street credibility among broadcast and print reporters alike. He joined WXYZ-AM Radio as a street reporter in 1965, covering the 1967 Detroit riots for the station. Channel 4 hired Bennett in 1968, where he stayed for 32 years. He drowned in 2004, four years after retirement. (Courtesy WDIV-TV)

The Channel 7 news team is pictured in the late 1960s. The team had already distinguished itself for its coverage of the 1967 Detroit riots. However, the station did not earn a number-one status in news for several years. Bonds remained on the job, on and off, for three decades. Diles went on to a long career and did the sports scores on the ABC-TV network. Morris also went on to a lengthy career at KABC-TV in Los Angeles. (Courtesy WXYZ-TV.)

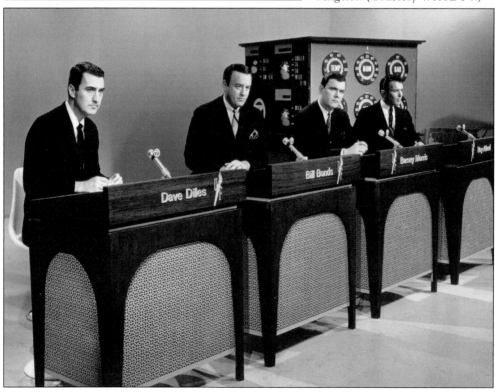

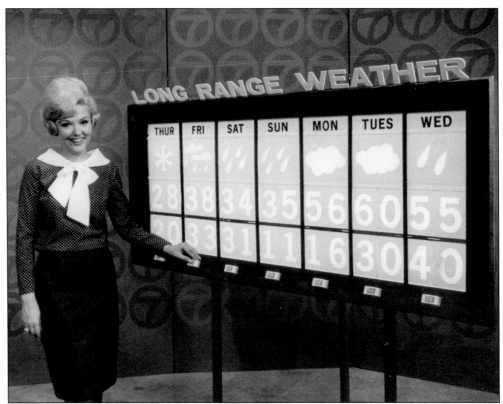

Pat Morris is serving up the weather on Channel 7 in the mid-1960s. She anchored a women's news program from 1963 to 1964, which was an innovation as nobody knew if a market existed for such a broadcast. The news program was written by a young Erik Smith, who went on to fame as an anchor at the station. Morris later went on to report the weather but was replaced by Trudy Haynes. (Courtesy WXYZ-TV.)

Trudy Haynes worked the Channel 7 weather desk between 1963 and 1965. She had already worked as a broadcaster at WCHB-AM between 1956 and 1963. Haynes was one of the first African Americans on Detroit television. General manager John Pival received grief for the decision, but he held firm. Haynes later went on to a long career at Philadelphia's KYW-TV. (Courtesy WXYZ-TV.)

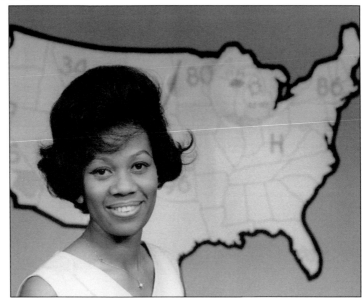

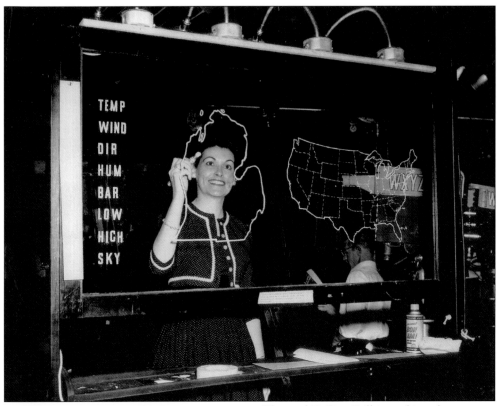

Channel 7's Rita Bell is working the weather desk. Channel 7 general manager John Pival discovered her singing at a Wrigley's grocery store corporate event. She later went on to considerable fame as a movie host. (Courtesy WXYZ-TV.)

Channel 4's Dwayne X. Riley, who worked in the station's news department for 34 years, could do just about anything. He covered hard news and special assignments, but then he became the go-to guy for soft features. His "Riley's World" segment became a nightly tagline for Channel 4's newscast. (Courtesy the *Detroit Free Press*.)

Channel 2 anchorwoman Beverly Payne started at the station as a receptionist before the brass put her on the air in 1973. Her cool charm and beauty made her one of Detroit television's best-known figures. (Courtesy the *Detroit Free Press*.)

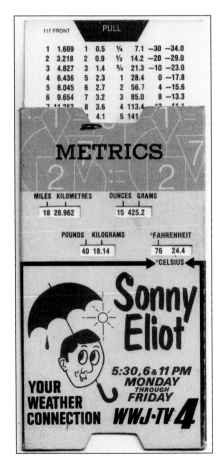

In the early 1970s, the United States was trying to join the rest of the world and go metric. Somebody had the idea that involving Sonny Eliot in the process might help. Here is a 1973 metric converter with an Eliot caricature. (Courtesy Ed Golick.)

An earnest, young Chuck Gaidica is hard at work at Channel 2. He replaced Sonny Eliot and then jumped to Channel 4. (Courtesy WJBK-TV.)

Channel 4's Mal Sillars was a real-life meteorologist who cared more about weather than he did about television. It earned him major credibility with viewers. He now sells real estate in Colorado. (Courtesy WDIV-TV.)

Dick Osgood's voice ushered Channel 7 onto the air in 1948. Osgood started at WXYZ-AM Radio in 1935, eventually becoming the "quizmaster" for *Radio Schoolhouse*. When television became big, Osgood made the transition, handling any number of assignments—as a newscaster, quiz show host, and entertainment reporter. Osgood died in 2000, just shy of his 100th birthday. (Courtesy the *Detroit Free Press*.)

Meteorologist Jerry Hodak is a Detroit native and graduate of Denby High School. He began his career at Channel 2 in 1965. His role model was Everett Phelps, a Wayne State University physicist who was one of Detroit's first television weathercasters. Phelps conveyed a scholarly approach to the weather, which Hodak continues to this day. Some 44 years later, he is still on the front lines. (Courtesy WXYZ-TV.)

Weathercaster Marilyn Turner is prepping for a Channel 2 newscast during the late 1960s. (Courtesy Walter P. Reuther Library, Wayne State University.)

Channel 7's Marilyn Turner is pictured on the new set in the early 1970s. (Courtesy Walter P. Reuther Library, Wayne State University.)

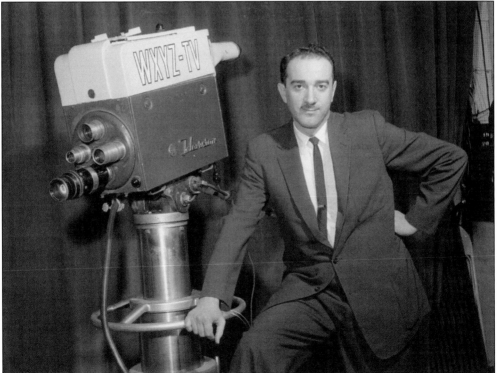

Peter Strand was a key architect in Channel 7's success. Soupy Sales, Johnny Ginger, Rita Bell, and Lady of Charm all reported to Strand, the station's programming chief. He was first hired a month before the station went on the air. Strand went to work at Chicago Public Television after leaving Channel 7 in the late 1960s. (Courtesy the *Detroit Free Press*.)

Don Wattrick is at the sports desk. He went on to work as the general manager of the Detroit Pistons in 1964. (Courtesy WXYZ-TV.)

Here is the "ole announcer," Van Patrick, in the 1940s. In addition to working as a sportscaster, Patrick was part owner of WKNR-AM Radio and was considered a smart businessman. (Courtesy Detroit Lions.)

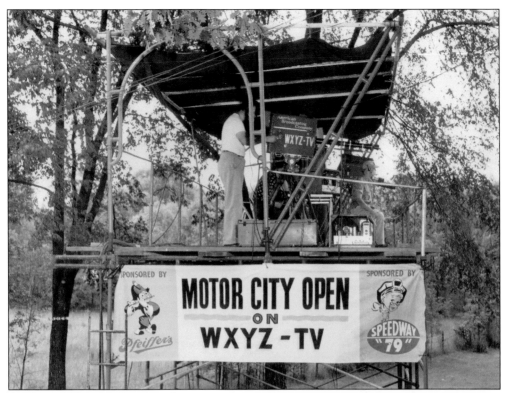

A Channel 7 crew is covering the Motor City Open at Royal Oak's Red Run Golf Club in the mid-1950s. Channel 7 general manager John Pival pushed for remote broadcasts at a time when remotes were both complicated and cumbersome. (Courtesy Ed Golick.)

Jerry Blocker was Detroit's first African American anchorman. After joining Channel 4 as an education reporter in 1967, news director Jim Clark was under pressure to make Blocker the station's anchorman. Blocker argued with the move, telling management he needed more seasoning. He got the job anyway and performed admirably. (Courtesy Nicole Blocker.)

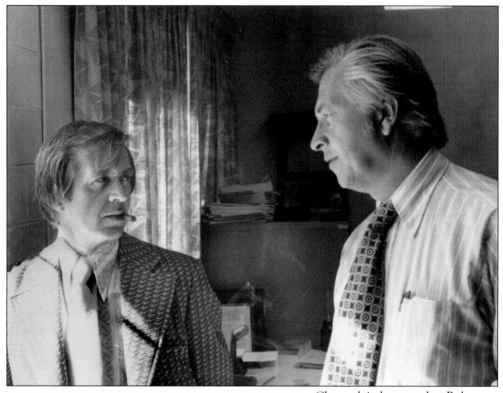

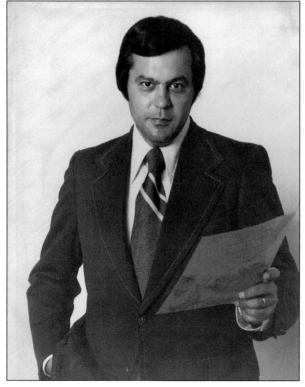

Channel 4 photographer Bob Stevens (left) and Channel 2's Joe Weaver (right) were two of broadcast news's warhorses. Both covered virtually every kind of story imaginable. Stevens worked at Channel 4 for 44 years, from 1955 to 1999; Weaver worked at Channel 2 for 35 years, beginning in 1963. (Courtesy Bob Stevens.)

Pictured is Channel 2's Vic Caputo, who was on the job between 1962 and 1980. He resigned to make a run for a congressional seat representing metro Detroit's east side, but he narrowly failed. He moved to Tuscon, Arizona, where he worked as a newsman before retirement. (Courtesy Vic Caputo.)

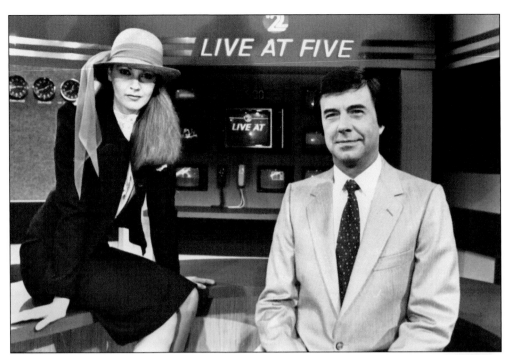

Channel 2's Joe Glover is getting a little help on the set from model Cyndi Meyers. He did two stints as a WJBK-TV anchor. Glover became disillusioned with broadcast journalism, and he took two years off to teach scuba diving. Glover now teaches journalism at the University of South Alabama. (Courtesy Walter P. Reuther Library, Wayne State University.)

Don Ameche was brought aboard at Channel 7 in the early 1960s as a movie host. The station's programmers dreamed up the idea of bringing a touch of Hollywood to town. He is spotted here in downtown Detroit in front of the Book Cadillac Hotel. (Courtesy the *Detroit Free Press*.)

Channel 7's Dave Gilbert is gathering the news in the 1970s. Photographer Sue McGill is behind the camera. (Courtesy Sue A. McGill.)

Byron MacGregor was the first anchor of Channel 50's 10:00 p.m. (WKBD) newscast. He initially earned his fame on CKLW-AM's 20-20 news. He also achieved national fame with his recording of "The Americans." (Courtesy Jo-Jo Shutty MacGregor.)

Jo-Jo Shutty MacGregor is thought to be the first airborne traffic reporter on the radio. Her performances on the legendary CKLW-AM ("the Big Eight") brought her celebrity status. Her marriage to newscaster Byron MacGregor made them the celebrity couple of 1970s Detroit. Channel 2 hired her as a weathercaster, a job she held for two years beginning in 1977. (Courtesy Jo-Jo Shutty MacGregor.)

Channel 7's Diana Lewis is looking serious shortly after her arrival in Detroit in the mid-1970s. She was already a star, appearing in the film *Rocky*. News director Phil Nye later explained why Lewis was moved to the anchor position. "It was her energy," he recalls. "She always kept up a pace, and I thought that would force Bill Bonds to kick things up a notch." (Courtesy Walter P. Reuther Library, Wayne State University.)

Bill Bonds poses at the height of his career in the 1970s. The American Broadcasting Company farmed him out to Los Angeles during the late 1960s and again to New York in the mid-1970s. He always returned to his home turf. (Courtesy WXYZ-TV.)

Channel 4's Carmen Harlan is pictured in 1981 not long after becoming the station's coanchor. (Courtesy Walter P. Reuther Library, Wayne State University.)

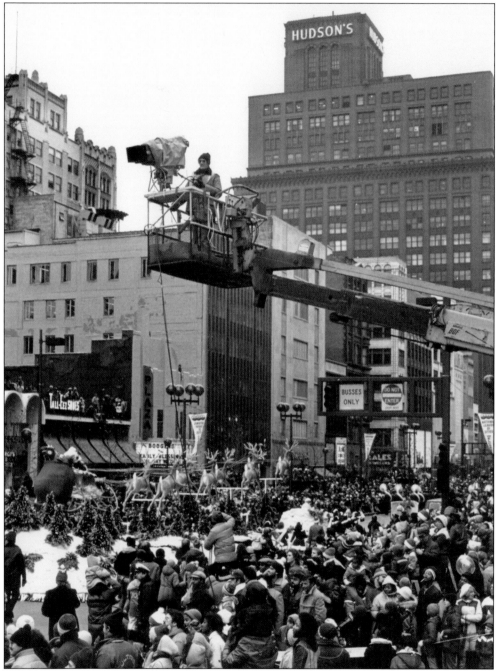

A Channel 7 crew is working the Thanksgiving Day Parade around 1981. The Hudson's Building is now gone. The Plaza Theater was showing *Deadly Blessing*, a Wes Craven horror show special. (Courtesy WXYZ-TV.)

Four

HOSTS

Hosts were the guides to almost everything—from movies, to the spectacular outdoor life of northern Michigan, to the world. These same people were also incredible characters. Movie host Bill Kennedy, at times, seemed like a slightly berserk duke. George Pierrot and Mort Neff felt like kindly uncles; Pierrot the uncle who had been everywhere and Neff the uncle who knew everything there was to know about fishing and hunting.

These were the people who gave television its personality . . . and what a personality it had.

A trim George Pierrot poses in 1941 at age 43, a half-dozen years before his first television appearance. He had already distinguished himself as a magazine editor, author, and host of the Detroit Institute of Arts's *World Adventure Series*. He was, perhaps, the only Detroit television star who was born in the 19th century. (Courtesy Walter P. Reuther Library, Wayne State University.)

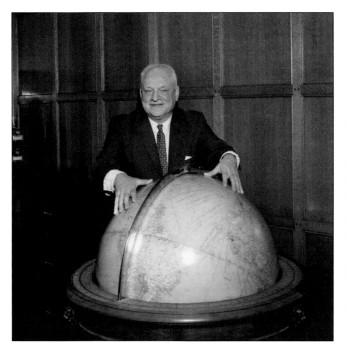

Pierrot is pictured here in 1958. The globe was, indeed, his playground. In a typical week, Pierrot could be found airing travel films from Scandinavia, Turkey, Chile, and Tahiti. During the early 1960s, his show aired seven times a week on Channel 4 and weekly on Channel 7. That kind of exposure gained him plenty of credibility with Detroit television viewers. (Courtesy Walter P. Reuther Library, Wayne State University.)

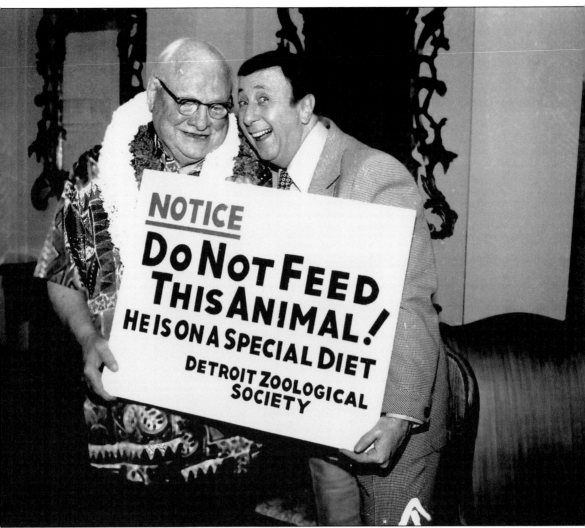

Pierrot shares the limelight with weatherman Sonny Eliot at his 80th birthday party in 1978. Pierrot's birthday bash at the Detroit Institute of Arts drew 2,000 guests. His television career was virtually over by then, but what a run it was from the late 1940s until the late 1970s. (Courtesy Walter P. Reuther Library, Wayne State University.)

George and Eleanor Scotti hosted one of the earliest musical programs on WWJ-TV. Working at the piano with a portable record player, the duo offered live musical numbers along with clever record pantomimes, covering everything from Spike Jones to Schubert. (Courtesy Ed Golick.)

Sonny Eliot, donning a long tie, is on the set of Channel 4's *Glen and Mickey*. (Courtesy Walter P. Reuther Library, Wayne State University.)

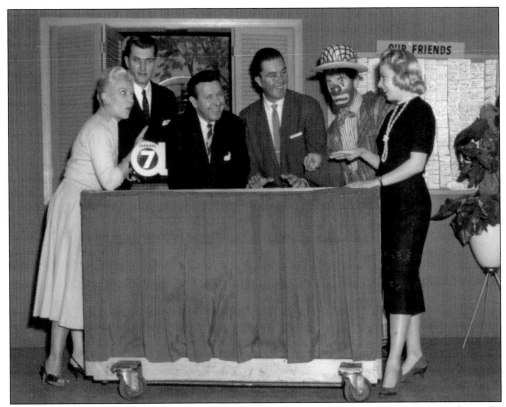

This is the cast of *Our Friend Harry*, which starred comedian Harry Jarkey and aired on Channel 7 between 1957 and 1959. The two-hour daily variety show tried to please everybody. Jarkey described it as a "local show with a homey atmosphere to please all ages." He is pictured here with a few of his friends. They are, from left to right, Jean Loach, Dick Femmel, Jarkey, Larry McAnn, Ricky the Clown, and Marion Rivers. (Courtesy Harry Jarkey.)

Johnny "Scat" Davis is in full scat mode for his variety show. Joe Messina is the guitarist in the foreground. Messina went on to become one of Motown's "Funk Brothers," the group of ace musicians who created the label's distinctive sound. (Courtesy WXYZ-TV.)

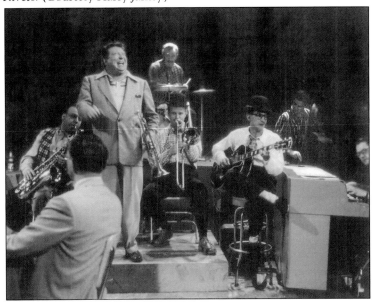

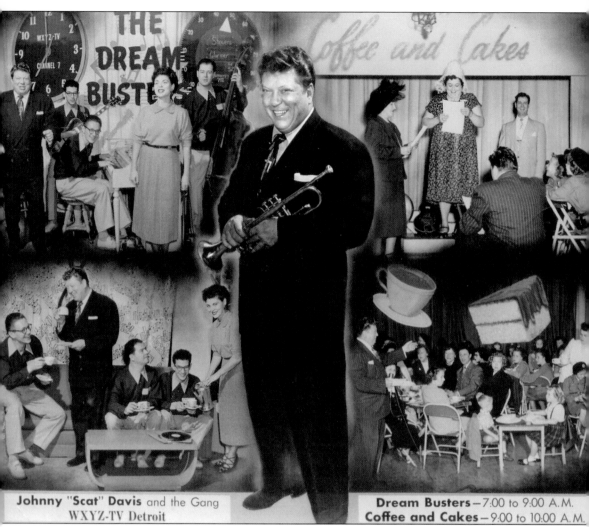

Johnny "Scat" Davis and the Gang
WXYZ-TV Detroit

Dream Busters—7:00 to 9:00 A.M.
Coffee and Cakes—9:00 to 10:00 A.M.

In addition to his nighttime variety show, Johnny "Scat" Davis hosted two morning shows, *Dream Busters* and *Coffee and Cakes*. A trumpet player, bandleader, actor, and singer, Davis is best known for singing "Hooray for Hollywood" in the 1937 musical *Hollywood Hotel*. (Courtesy WXYZ-TV.)

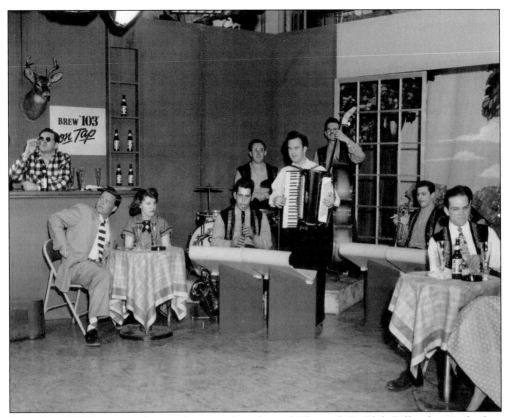

Stan "Stosh" Wisniach, playing the accordion, hosted Channel 7's Club Polka during the late 1940s and early 1950s. Channel 7 general manager John Pival discovered Wisniach at the Tip Top Club and made him a star. The show was a Friday night favorite. (Courtesy WXYZ-TV.)

Betty Bahr is serving drinks on the set of Club Polka. The brew of choice was E & B beer, the show's sponsor. Bahr did just about everything, including ads and variety shows. (Courtesy WXYZ-TV.)

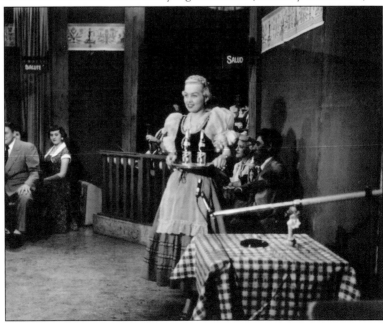

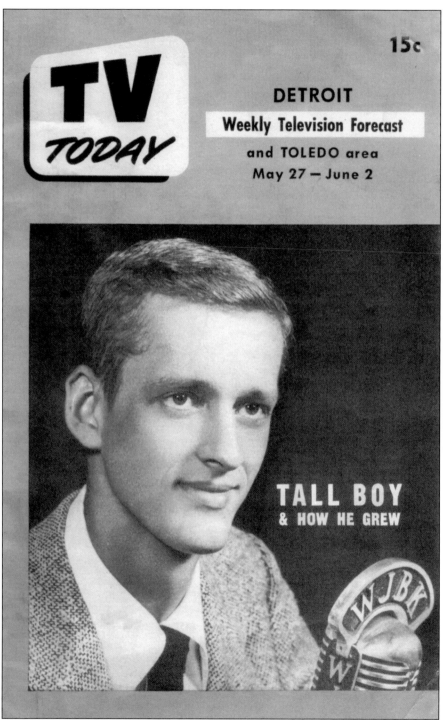

Bob Murphy was the *Tall Boy in the Third Row.* He was not miscast, as he was 6 feet, 8 inches tall. He worked on both radio and television during the 1950s. Murphy joined WJBK-AM in 1948 before transforming himself into a morning-show host. His programs included *Ladies Day, Breakfast With Murphy,* and *The Morning Show.* (Courtesy Ed Golick.)

Loree Marks, seen here as the sultry White Camellia, hosted romantic movies for WXYZ-TV in the mid-1950s. Marks was also the Restokraft Mattress girl for *Soupy's On*, Soupy Sales's nighttime variety show. (Courtesy Ed Golick.)

Singer/host Auntie Dee (Dee Parker) is rehearsing with pianist Leonard Stanley in the early 1950s. (Courtesy WXYZ-TV.)

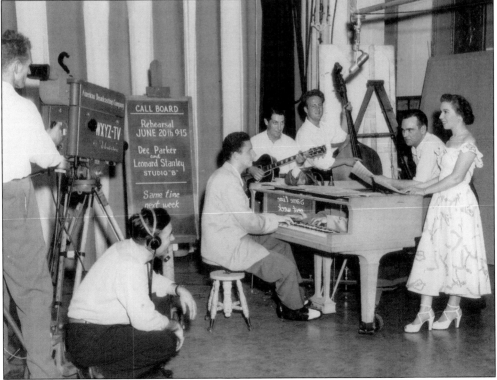

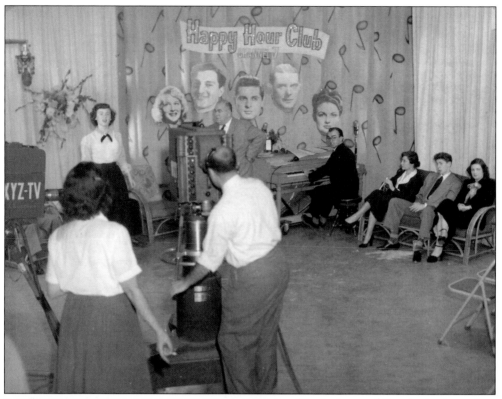

Pianist Leonard Stanley is pictured with his band. He transitioned from radio to television and hosted two shows at Channel 7, *Melodies 'n' Money* and *Songs For Your Supper.* (Courtesy WXYZ-TV.)

A young Edythe Fern Melrose stands behind the microphone. She managed WJLB-AM Radio at a time when women had little place in broadcasting. She later morphed into Lady of Charm and hosted a show by the same name that became one of Detroit television's most popular and lucrative programs. (Courtesy WXYZ-TV.)

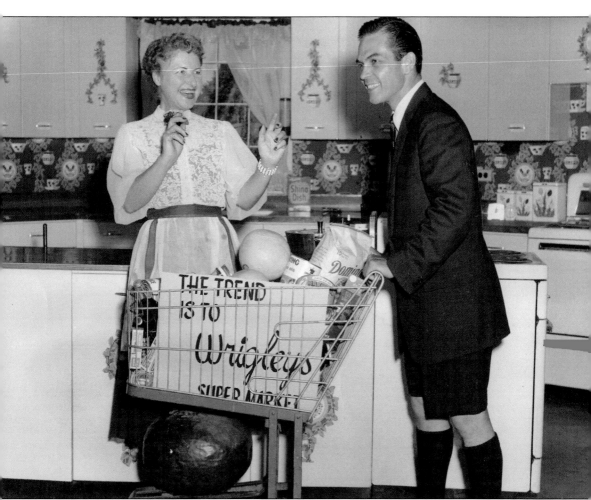

The Lady of Charm instructed Detroit-area women on how to cook, dress, clean, and talk. She was also known as a tough, two-fisted businesswoman who was not to be crossed. She reportedly made more money from endorsements than any of the station's executives. She is spotted here with announcer Larry McCann. (Courtesy the *Detroit Free Press*.)

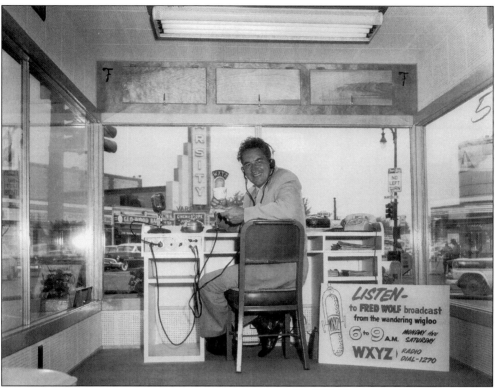

Fred Wolf was one of Detroit radio's biggest stars, and he also worked as Channel 7's go-to guy hosting bowling shows and hot rod races among other things. (Courtesy WXYZ-TV.)

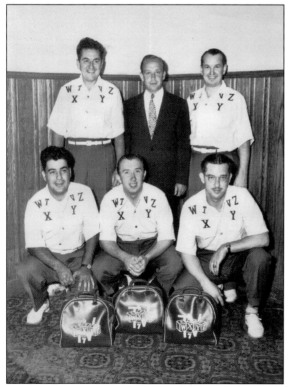

This is the WXYZ-TV bowling team. Fred Wolf is to the back left, and the guy in the suit is James Riddell, who left Channel 7 to become chief of ABC's West Coast operations. Wolf was a serious bowler who held a spot on the legendary Stroh's bowling team. A back injury forced him out of the sport and into broadcasting. (Courtesy Ed Golick.)

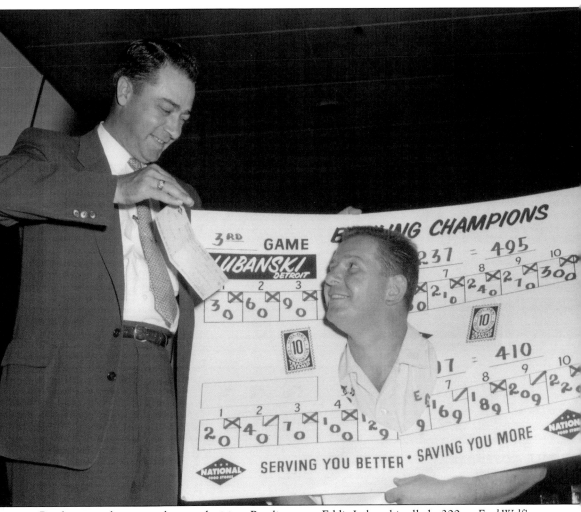

Bowling was always popular on television. Bowling great Eddie Lubanski rolled a 300 on *Fred Wolf's Bowling Champions* on Channel 7. That match proved to be lucrative. Here is Lubanski receiving a check for $10,000 from the show's sponsor, National Food Stores. (Courtesy Ed Golick.)

Mary Morgan helmed the Channel 9 movie show, *Million Dollar Movie*, during the 1950s. Her dog Liepchen became almost as famous as Morgan. (Courtesy the *Detroit Free Press*.)

Mort Neff, of *Michigan Outdoors*, is poised with his weapon of choice indoors in 1960. (Courtesy Walter P. Reuther Library, Wayne State University.)

Mort Neff is pictured with colleagues in winter 1950 in Neff's native habitat—the outdoors. They are preparing to make sound recordings in Standish. (Courtesy Walter P. Reuther Library, Wayne State University.)

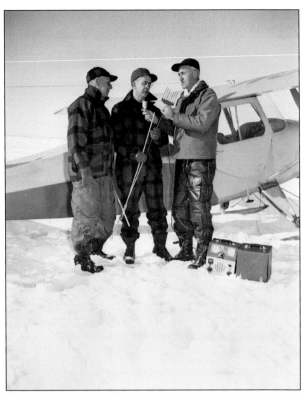

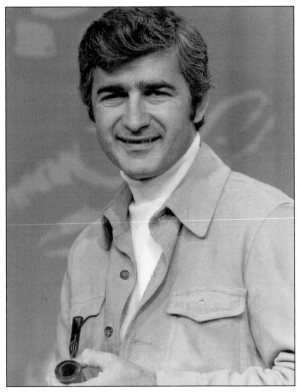

Jerry Chiapetta became the outdoor meister when Neff retired. (Courtesy WXYZ-TV.)

Only Channel 50 movie host Bill Kennedy (and maybe Steve Martin and Tom Wolfe) could get away with wearing a white suit. (Courtesy WKBD-TV.)

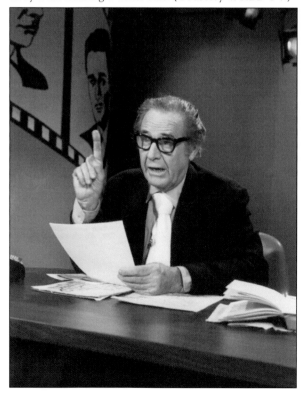

Bill Kennedy makes a point about a movie, which is something he did often during a career that ran from 1953 to 1983. (Courtesy WKBD-TV.)

Warren Michael Kelly had a Channel 7 morning show, *Warren Michael Kelly Entertains*, during the early 1950s. His program featured a combination of news, music, and conversation. Note the cigarette, which, thank goodness, was not in the mix. (Courtesy the *Detroit Free Press*.)

Channel 7 general manager John Pival discovered Rita Bell singing in a Wrigley's supermarket. He hired her to do the late-night weather, but before long she was given the morning shift as host of WXYZ-TV's *Prize Movie*. (Courtesy WXYZ-TV.)

Rita Bell appears as a schoolmarm in ABC-TV's *The Big Valley*. Since WXYZ was an ABC owned-and-operated station, many of its talent did walk-on parts for the network, which they promoted on their programs. (Courtesy WXYZ-TV)

Crafty Carol Duvall conducted celebrity interviews on WWJ-TV's morning talk show *Living*. Before she left the station in 1976, she had coanchored the noon news, hosted a handful of fashion shows and women's issues programs, and appeared daily in a five-minute crafts program. From 1994 to 2005 she hosted HGTV's *The Carol Duvall Show*, where she reigned as the queen of crafters. (Courtesy WDIV-TV.)

Channel 4's Ed Allen hosted a fitness show from the late 1950s through the early 1970s. He was also a published author. (Courtesy Ed Golick.)

ED ALLEN'S

FITNESS
BROCHURE

for
MEN
and
BOYS

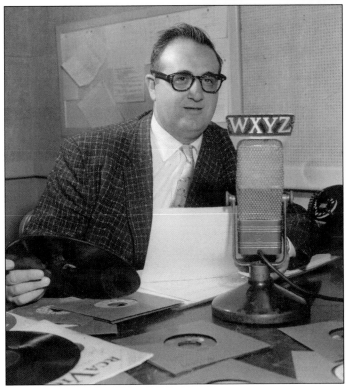

Mickey Shorr was the talent behind one of Detroit's early rock-and-roll television shows, *Mickey's Record Room*. Shorr was noted for his energy, and he seemed like everybody's cool big brother. He also invented his own jargon, such as a clock was a "time tellin' mo-sheen." (Courtesy the *Detroit Free Press*.)

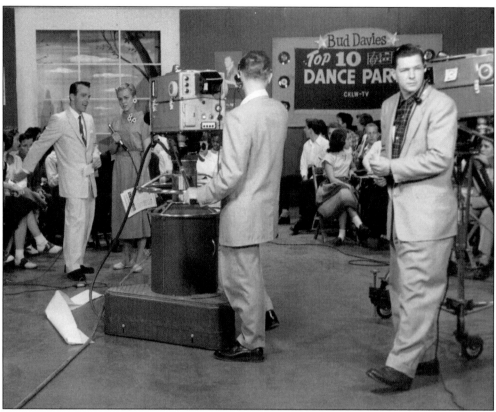

Channel 9's Bud Davies hosted *Top 10 Dance Party* during the 1950s. He also spun records at CKLW-AM, creating a powerful rock presence in metro Detroit. (Courtesy Matt Keelan.)

This is Channel 9's Robin Seymour, host of *Swingin' Time*. A young rocker by the name of Bob Seger got his start on the program, as did many Motown artists. Check out the high school pennants in the background. (Courtesy Matt Keelan.)

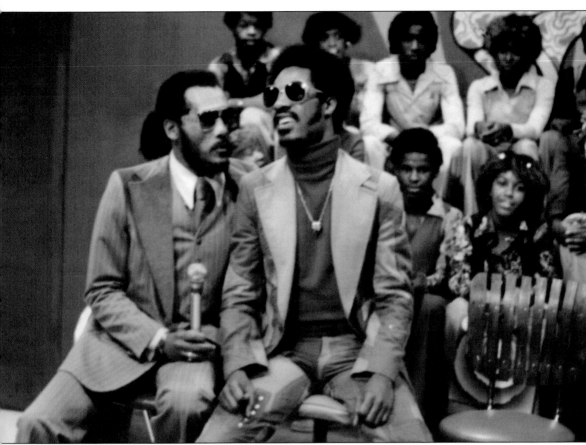

Nat Morris (left), host of WGPR-TV's *The Scene*, interviews Motown superstar Stevie Wonder. The show was a window into African American culture during the 1970s and 1980s. (Courtesy Nat Morris.)

Sergeant Sacto (Tom Ryan) is delivering his trademark double-pumper salute. The Channel 50 program started out as a kid's show but became a cult favorite among college students. The costume is a running suit that Ryan picked up in Europe while touring with the University of Detroit basketball team. (Courtesy Tom Ryan.)

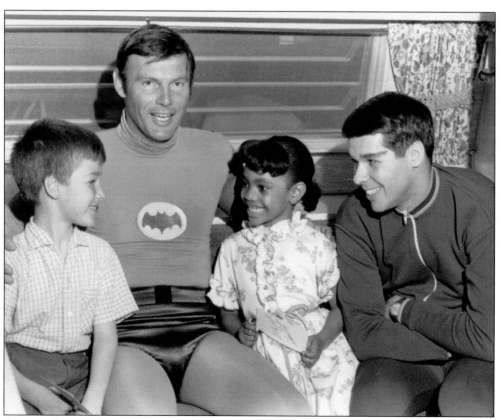

Sergeant Sacto and two young fans are schmoozing with Batman (Adam West). Ryan later joked, "I think I was more excited than the youngsters." (Courtesy Tom Ryan.)

Morgus the Magnificent first aired in New Orleans in 1959, but in the mid-1960s he packed up his laboratory and set up shop in Detroit, where he hosted a five-minute weather forecast at WJBK-TV. After a year he moved to WXYZ-TV, where he introduced late-night horror movies until he moved back to his hometown of New Orleans. In 2009, Sid "Morgus" Noel celebrated 50 years on television. (Courtesy Dave Muse.)

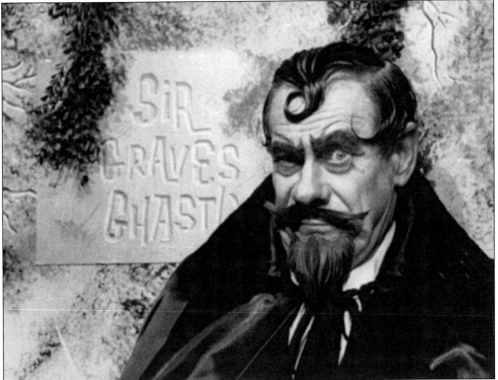

Turn out the lights . . . pull down the shades . . . cuddle up to a favorite spot by the telly . . . it is time for Detroit's resident vampire movie host, Sir Graves Ghastly. Lawson Deming played the lovable vampire from 1966 through 1983. During commercial breaks, Deming featured a cast of creative characters like the Glob, Baruba, Baron Boofaloff, and Tilly Troolhouse (one tough cookie). It was not a wooden stake that caused Sir Graves's demise; it was WJBK station manager Bill Flynn's axe that killed the show, along with a handful of other television personalities. (Courtesy WJBK-TV.)

The Ghoul is pictured in full regalia. Although The Ghoul (Ron Sweed) honed his act in his native Cleveland, it transferred well to Detroit television. (Courtesy Walter P. Reuther Library, Wayne State University.)

Fred Merle was a cult favorite on Channel 62's *Auction Movie.* Steaks were a favorite auction item. (Courtesy Fred Merle.)

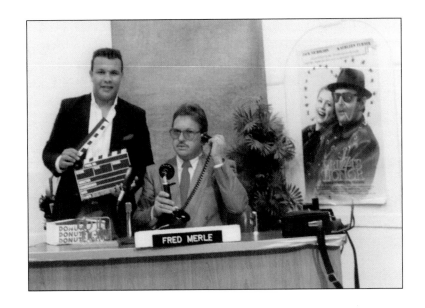

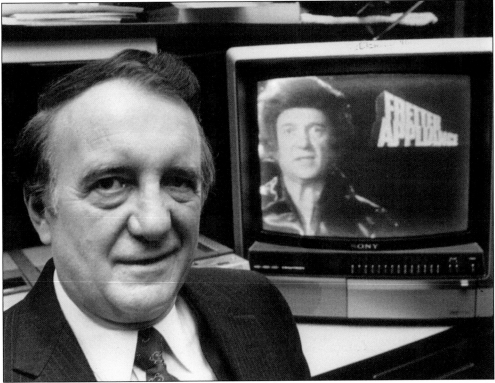

Ollie Fretter's mantra became part of the Detroit lexicon, "I'll give you five pounds of coffee if I can't beat your best deal. The competition knows me, you should too." Fretter started his business with a $600 loan from an uncle. At the height of his powers, the Fretter empire stretched to 242 stores in a half-dozen states. The company went under in 1996, when the big-box chain stores took over the business. (Courtesy the *Detroit Free Press.*)

John Kelly and Marilyn Turner are having a chat at Channel 7's studios in 1979. (Courtesy Walter P. Reuther Library, Wayne State University.)

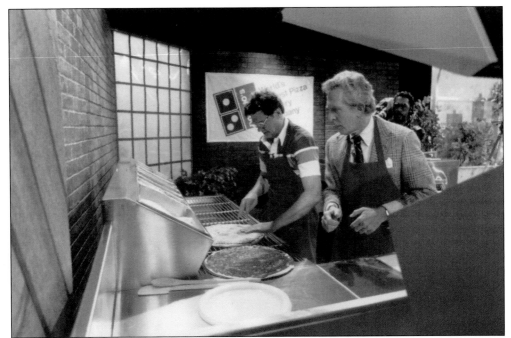

John Kelly (right) shares the kitchen with Domino's Pizza owner Tom Monaghan, who made millions flipping pizza. He sold enough pizza to buy the Detroit Tigers. (Courtesy WXYZ-TV.)

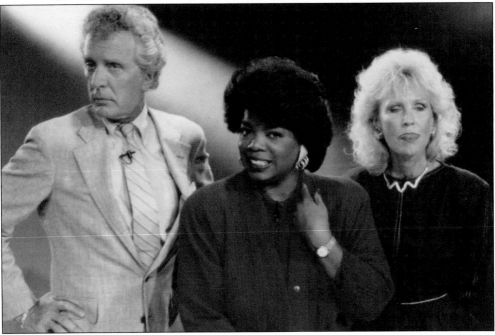

John Kelly and Marilyn Turner are pictured with budding television star Oprah Winfrey. Turner was there on a landmark day in 1995. Her program, *Kelly & Company* went off the air—the last locally produced, daily, non-news program on Detroit television. The evolution of syndicated programs, such as Oprah Winfrey's, was the reason local non-news television could not survive. (Courtesy WXYZ-TV.)

DISCOVER THOUSANDS OF LOCAL HISTORY BOOKS
FEATURING MILLIONS OF VINTAGE IMAGES

Arcadia Publishing, the leading local history publisher in the United States, is committed to making history accessible and meaningful through publishing books that celebrate and preserve the heritage of America's people and places.

Find more books like this at
www.arcadiapublishing.com

Search for your hometown history, your old stomping grounds, and even your favorite sports team.

Consistent with our mission to preserve history on a local level, this book was printed in South Carolina on American-made paper and manufactured entirely in the United States. Products carrying the accredited Forest Stewardship Council (FSC) label are printed on 100 percent FSC-certified paper.

MADE IN THE